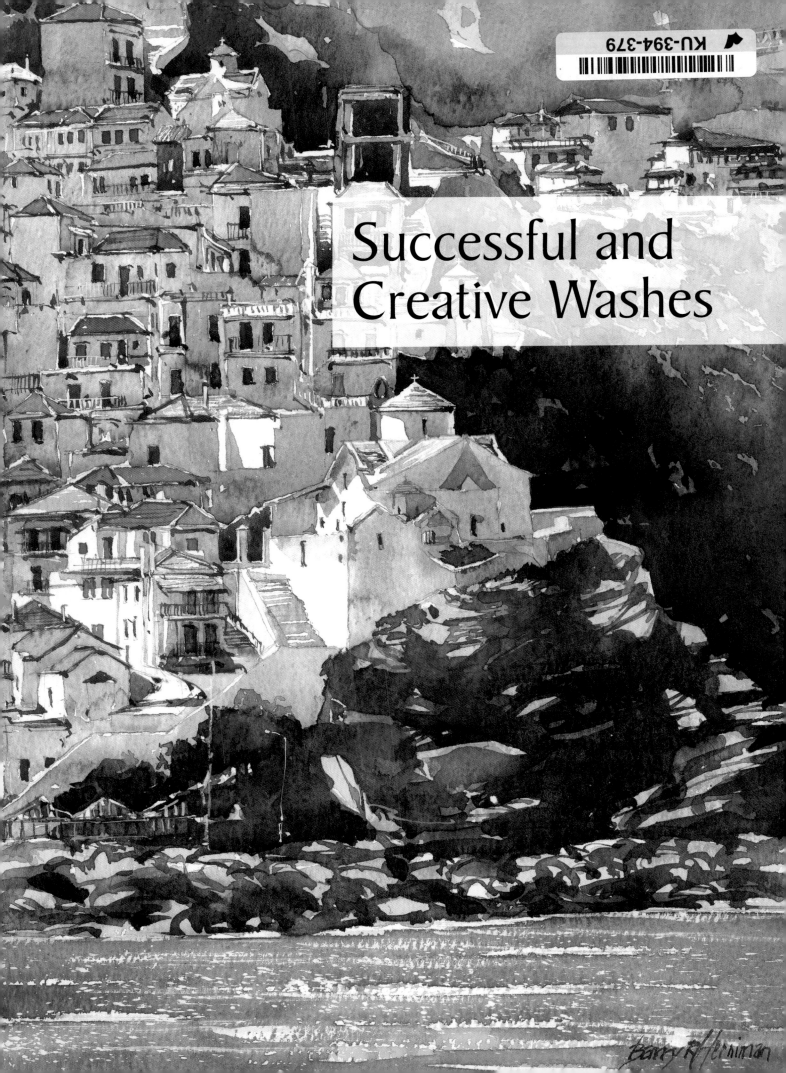

Successful and Creative Washes

*To Spikey and our four
remaining 'Niths'.*

Successful and Creative Washes

BARRY HERNIMAN

SEARCH PRESS

First published in Great Britain 2007

Search Press Limited
Wellwood, North Farm Road,
Tunbridge Wells, Kent TN2 3DR

ISBN-10: 1-84448-148-4
ISBN-13: 978-1-84448-148-4

Suppliers

If you have difficulty in obtaining any of the materials and equipment mentioned in this book, please visit the Search Press website for details of suppliers: www.searchpress.com

Alternatively, you can visit the author's website:
http://www.barryherniman.com/

for a current list of stockists, including firms who operate a mail-order service, or you can write to Winsor and Newton requesting a list of distributors:

Winsor & Newton, UK Marketing,
Whitefriars Avenue, Harrow, Middlesex HA3 5RH

Acknowledgements

My thanks to everyone at Search Press and Roddy Paine Photographic Studios, all of whom made the production of this work another pleasurable experience.

Publishers' note

All the step-by-step photographs in this book feature the author, Barry Herniman, demonstrating how to paint watercolour washes. No models have been used.

There are references to sable and other animal hair brushes in this book. It is the Publishers' custom to recommend synthetic materials as substitutes for animal products wherever possible. There is now a large range of brushes available made from artificial fibres, and they are satisfactory substitutes for those made from natural fibres.

Front cover
A Sprinkling of Gold
35 x 56cm (13¾ x 22in)
An early morning picture of Lake Pauline (Vermont, USA), where the sun was just catching the falling leaves.

Page 1
Into the Harbour
32.5 x 44.5cm (12¾ x 17½in)
The view from the ferry as you approach Skopolis harbour, Greece.

Pages 2–3
Light over Dingle from Connor Pass
47.5 x 35.5cm (18¾ x 14in)
A magnificent view of the Dingle peninsula in Ireland from the nearby Connor Pass.

Opposite
Afternoon Sun
48 x 36cm (19 x 14in)
A quiet afternoon at low tide: Staithes, Yorkshire.

Contents

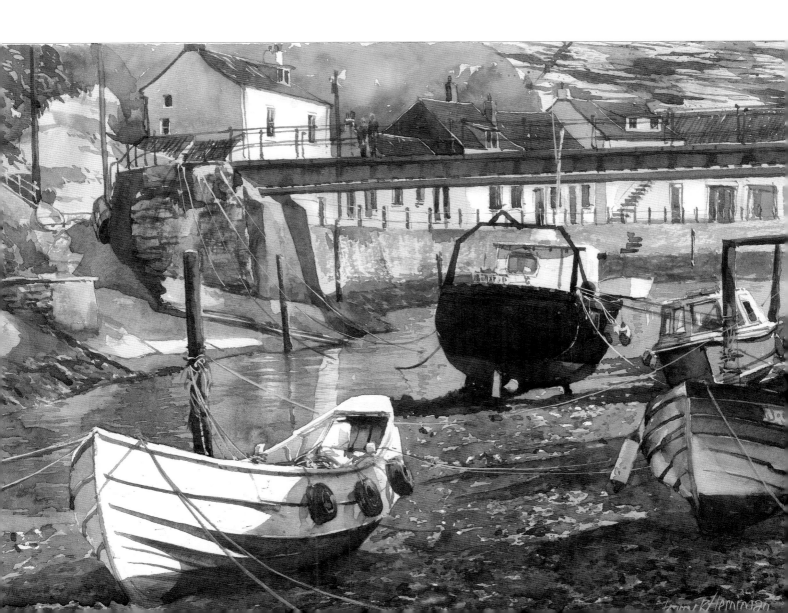

Introduction

I have always been fascinated by watercolour and started collecting books on the subject back in my teens. I would spend hours poring over colour prints of landscapes, marvelling at the way different artists would produce these glowing, vibrant watercolours, seemingly with such ease! The medium seemed so elusive, so delicate, that it was as if the paintings were produced by magic.

It will come as no surprise that I chose watercolours when I took up painting. My first forays into the medium were awful, to say the least, and I had grave doubts that I would ever get to grips with it; but I was determined, so I stuck with it.

Since then, I have painted in a whole array of different media, but I always come back to watercolour. There is no other medium that is so fluid, so transparent and, at times, so unpredictable. It is these qualities that keep pulling me back to watercolours when painting.

The watercolour wash is one of the fundamental techniques, but it is also one which is often overlooked or passed over. This approach is a bit like building a wall without first having learnt how to mix the mortar!

Watercolour painting is often thought of as difficult and unforgiving, and because of this many steer clear of it or give up on it early on. It is all too easy to overwork a watercolour or muddy the colours, leaving the whole piece dull and lifeless. However, if you follow my guidelines, you should be on your way to producing some wonderful results.

I have called this book *Successful and Creative Washes*, because that is exactly what I want to show you: how to be creative with this basic watercolour technique. The excitement of watching washes of pure colour colliding and fusing together never loses its appeal. Washes do not have to be boring! Keep practising, and in time a whole new repertoire will be open to you. Laying down colour in this way lets the watercolour do its own thing and can produce some super, spontaneous results.

So let's get the colour moving and let the magic begin!

Afternoon Shadows

65 x 50cm (25½ x 19¾in)
I cannot go to North Yorkshire without paying a visit to the magnificent little harbour village of Staithes. The light and mood change each time I visit, depending on the tides and time of day. I never tire of painting this place – the day I leave Staithes uninspired is the day I hang up my brushes.

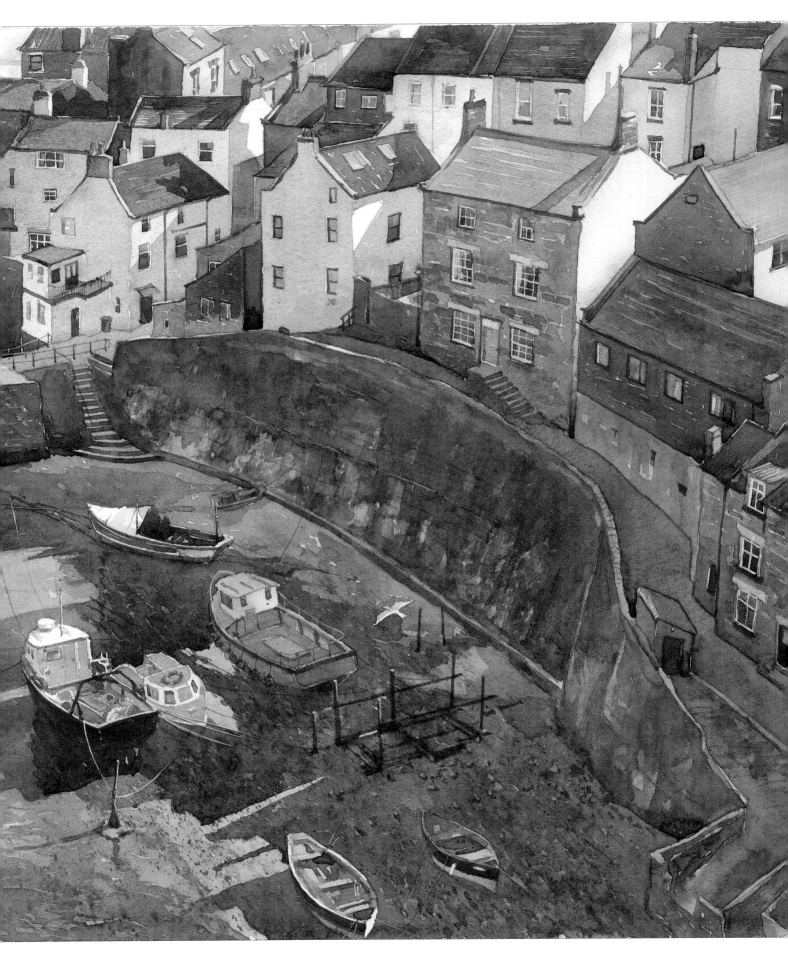

Materials

PAINTS

Paints, like all other painting materials, are to a great extent a matter of personal choice – both in terms of the manufacturer and the colours to use. My general rule is to keep your colour selection down to a minimum and get to know how they behave together and whether or not you like the final result.

Because I do a lot of glazing (laying one transparent wash of watercolour over another) all of my colours tend to be transparent or semi-transparent. In this book I rarely use any earth pigments such as umbers, siennas, sepia or light red. Similarly, I have no pre-mixed greys or greens. All of these colours can easily be mixed from the colours I have on my palette.

For the best results when applying washes, I recommend you use artists' quality paints rather than students' quality as the latter use a lot of binder, meaning that they can produce rather flat, semi-opaque results.

I use tube colours and squeeze fresh juicy paint into my palette before a painting session.

TIP

I use gouache for 'tickling in' any little fiddly details that remain at the end of a painting session. A little gouache mixed with yellow makes light work of tall grasses!

PALETTES

Palettes come in a bewildering array of shapes, sizes and materials. In the studio I tend to favour porcelain mixing palettes with deep wells. These hold a lot of pigment, are heavy so they do not move about and are very easy to clean. My travelling paintbox is handmade in brass and contains six deep mixing wells and a compartment to hold fourteen colours.

TIP

Always try to get the best materials that you can afford, rather than trying to save money with poor quality equipment. Buy less, and buy the best!

BRUSHES

Brushes are a minefield. You can spend so much on them only to be disappointed with their performance or longevity. Because I give my brushes such a hammering (especially in the field), I tend to use a synthetic sable mix. This way I get the colour-carrying capacity of the sable and the hard-wearing properties of the synthetic.

I would recommend size 8 and size 12 round brushes when starting out, but always use the largest brush you feel happy with, as smaller brushes do not hold as much paint and can produce dry-looking passages in your painting.

A special mention ought to go to riggers. These long, fine brushes hold a lot of paint, and are ideal for grasses and fine detail.

TIP

This is the brush that I use for lifting out (see page 16). I made it from an old hog hair brush by using a craft knife to cut the bristles off at an angle.

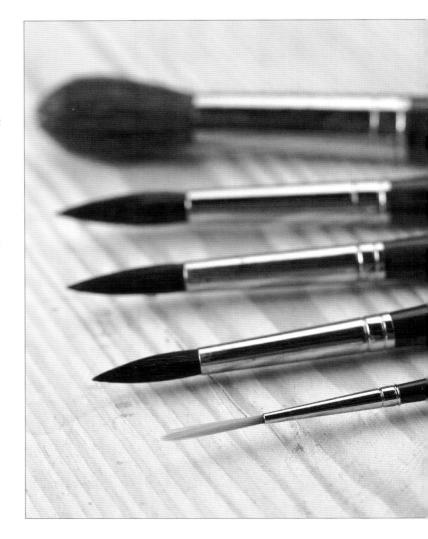

9

Drawing board

Because I like to move my colours around a lot, I use a series of very lightweight drawing boards to hold the paper. These are made up of two sheets of foamcore board stuck together.

My travelling board is covered with a non-slip plastic material which allows me to use my blocks or sketchbooks at an angle without them sliding about.

Watercolour paper

There are some fabulous papers on the market now, and some are very reasonably priced. So many times I have seen people pay out a small fortune on paints and brushes but use cheap and nasty paper. Use cheap by all means – but steer clear of nasty!

For your colours to work well you must have a suitable support or your colours will go dead. I use heavyweight 640gsm (300lb) rough finish and Not finish paper in the studio. In the field, I use a sketchbook which contains 300gsm (140lb) rough paper in A4 and A3 formats.

WATER POTS

I use a large collapsible water pot
which holds a good amount of
water, and is also very lightweight
and easy to transport.

OTHER MATERIALS

Masking fluid and brush A great tool but one that can be overused. Masking fluid prevents
paint from touching your painting surface, allowing you to preserve the white of the paper.
It can be tinted with a little watercolour paint to help you see it. Masking fluid has a very
limited shelf life and can become very tacky in time. Beware of using old masking fluid, as
you may find it difficult to remove.

Masking tape 2½cm (1in) wide masking tape is ideal for ensuring a crisp edge on your
finished paintings.

Craft knife A handy general-purpose tool, but do not take it on a plane!

Squirt bottle This great little tool is handy for keeping paints wet and also for adding special
effects to paintings.

Hairdryer This is used for speeding up drying times of damp washes, but do not use it on
very wet washes as it can push the pigment around and result in a patchy finish.

Pencil A propelling pencil with a 0.7mm 2B lead is used for the initial drawings.

Slide viewer As the name suggests, this is great for viewing slides for reference.

Kitchen paper Always have a good supply of kitchen paper to mop up, lift out and clean up.

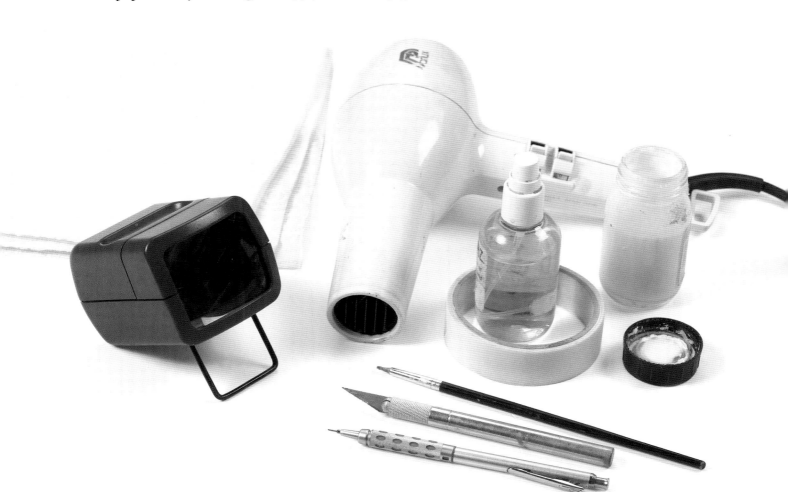

Techniques

USING PAINT

Preparing paint

The word 'watercolour' is made up of two parts: water and colour (i.e. pigment). How much of one you mix with the other is a crucial factor when painting – and particularly so when preparing paint for washes. If the wash is too wet, the paint runs away, leaving a weak and insipid wash. Too dry and the wash sits and becomes heavy and less transparent.

Here I have mixed up three wells of pure colour to a top-of-the-milk consistency: pure yellow, rose madder and cobalt blue. This consistency is ideal for washes, being light but strong.

These colours are the only ones used throughout this chapter, but the results of using them properly gives you a great variety of colours and effects for your paintings.

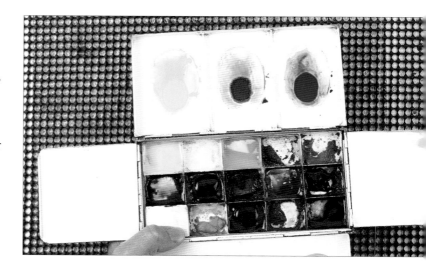

Mixing paint on the palette

When mixing on a palette, the aim is to mix but not overmix your paints. Let the colours have a chance to do their own thing; the results will surprise you!

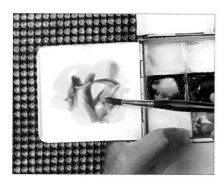

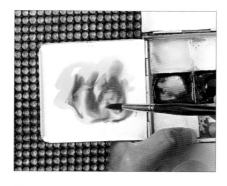

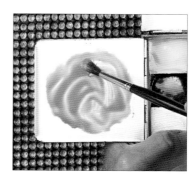

1 Put two colours together on the palette. Do not be tempted to scrub with the brush. The colours will bleed into one another.

2 The same is true even if you add a third colour. Using the intermingled colours to paint will keep your colours lively, bright and translucent.

TIP

Do not overmix your paints. If you scrub the colours with the brush, all of the freshness of the colours is lost.

Mixing on the paper

The same lesson goes for mixing on the paper: mix but do not overmix.

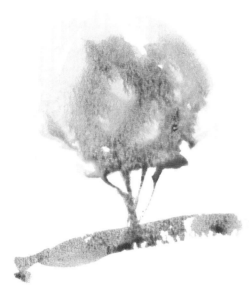

This tree has been painted by laying blue wet in wet on to a yellow shape. Notice how the colours blend on the paper into a fresh, bright green. Touches of red were then added to form the trunk. Again, they bleed into a warm, lively brown.

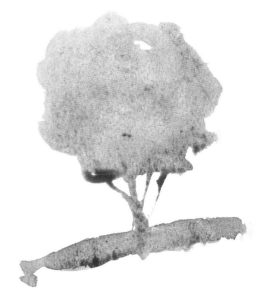

In contrast, the three pigments here have been well and truly mixed together, making a flat, lifeless shape.

Backruns or 'cauliflowers'

Backruns are caused by touching a loaded wet brush against a wash that has started to dry. The half-dry wash on the paper acts like a sponge, sucking the water out of the brush. This causes the half-dry wash to dry unevenly and deposit the pigment in an unattractive cauliflower shape.

To avoid backruns, make sure that you only lay a new wash into a completely dry area.

1 A backrun is formed when you work into a wash which is damp rather than wet. Here, this perfectly fine area of colour is going to be ruined by fiddling!

2 Adding wet colour on to the edge of this damp area pulls the water from the colour into the damp area – but the pigment is heavier and is left behind. When the paint dries, a backrun is formed, as shown above.

TIP

When drying your work, use the back of your hand to touch the paper. If it feels cool, there is still water vapour present. Leave it until it is bone dry.

Dip dip dip

This is a technique that I use for speed in applying areas of fresh, semi-mixed paint. It is great for producing passages of broken colour in a controlled way.

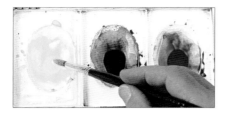

1 Prepare your colours and load your brush with the lightest of the colours.

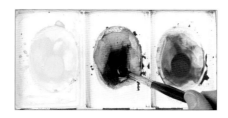

2 Dip the brush quickly into the second colour.

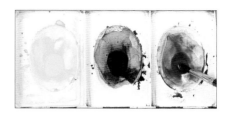

3 Dip your brush quickly into your third colour.

4 When you begin to paint, you will notice how the colours are slightly merged, but the separate hues are still visible.

Notice the subtle variation in the colours that appear in the shape.

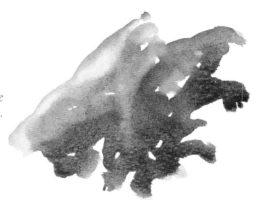

Spattering

This technique is useful for producing lively areas of random colour, and is especially effective for foliage; using a 'flick and tickle' approach. It can be rather uncontrollable, so cover up any area where you do not want blobs of paint.

1 Load your brush and flick it at the paper so that some of the paint spatters across the page

2 This can be repeated with another colour. Use the tip of the brush to intermingle the colours and tickle the spattering into the shape you want.

3 Further paint can be flicked over the top, and either tickled into place or simply left to blend with the other colours.

Glazing

Glazing is laying one transparent layer of watercolour over another. By using transparent colour, you ensure that the colours enrich one another without becoming obscured or dull. Each subsequent colour will be affected by the colour or colours underneath it, producing areas of great depth and luminosity.

Tip

When glazing, it is imperative that each wash is bone dry before the next wash is applied.

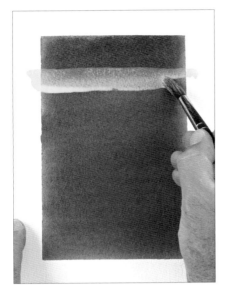

1 Load your brush with thinned paint and draw it over your dry painting.

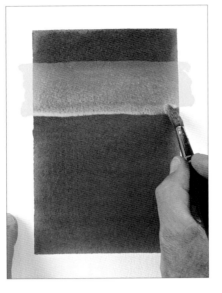

2 Continue over the area you wish to glaze. Note how the colours interact with one another.

Here I have layered successive glazes over one another for different effects. Allow each glaze to dry before applying the next.

Using masking fluid

Masking fluid is a brilliant tool, but one which is so commonly overused! I use it only where I need to preserve the white paper in a large area having a wash applied – otherwise I paint around the area, which gives a more painterly final result. I never use masking fluid in the field.

Tip

You can use a cheap old brush, a twig or anything that leaves a painterly mark to apply masking fluid. Do not use your good brushes, as it will ruin them.

1 Masking fluid can be applied by spattering, or more precise lines can be made with a brush.

2 The masking fluid will prevent any paint from colouring the paper, so be careful to use masking fluid only where you want it.

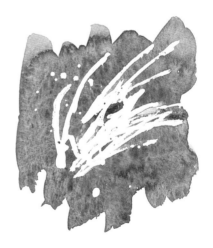

3 Once dry, you can paint over the masking fluid. Once the paint dries, rub the masking fluid off using your thumb.

LIFTING OUT

Once you have paint on the paper, you can never get the pure white of the paper back. However, you can produce light areas within an area of colour by lifting out. This is particularly useful for grasses, highlights on rocks and so on.

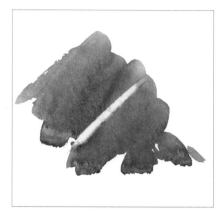

1 Make sure your wash is completely dry, and use clean water to draw a line on the paint.

2 Dab kitchen paper on to the wet area. This will lift out some of the pigment.

Lifting out is quite precise, so it is useful when you are working on fine details.

BLOTTING

This technique is useful for producing random light areas of colour. It is a superb effect for rocks and pebbly beaches.

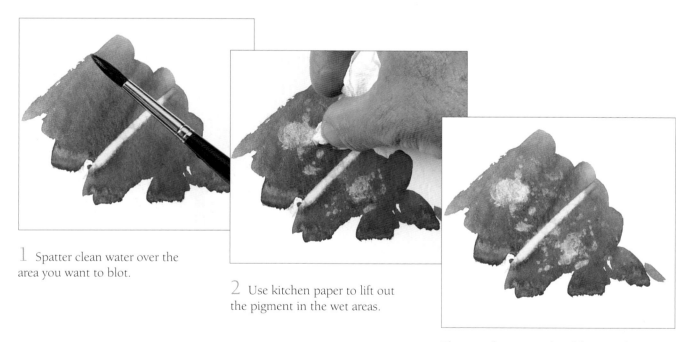

1 Spatter clean water over the area you want to blot.

2 Use kitchen paper to lift out the pigment in the wet areas.

Blotting is less precise than lifting out, but is useful for creating a lively painting.

DRY BRUSH

This technique is ideal for producing texture on both rocks and cliffs, and is also lovely for sparkles across water.

Load your brush, and then wipe it on kitchen paper to remove most of the paint. Drag the brush hard across the paper, pushing the ferrule on to the paper.

USING THE END OF A BRUSH

I use this technique when I want to pull details out of a wash.

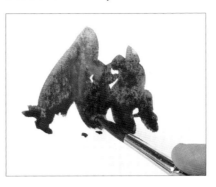

1 Paint your rock. Here I have used the dip dip dip technique from page 14.

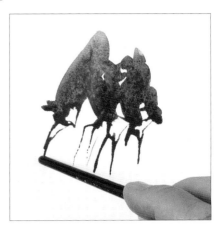

2 While the paint is still wet on the paper, draw the handle end of a brush through the colour and down over the paper. You can also draw the paint between the vertical lines to create further texture.

OTHER TECHNIQUES

These techniques are not used in the projects, but you may wish to try them out when you start your own compositions.

Salt

Adding salt to a damp wash produces a random texture. The effect will vary depending on how wet or dry the wash is before the salt is applied.

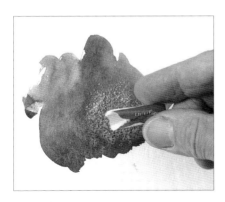

1 On damp paint, pour a small quantity of salt crystals.

2 Allow the paint to dry completely, then brush the salt off using your finger. The salt absorbs a little of the paint, leaving an interesting texture on the paper.

Scratching out

This technique is great for punching in sparkles on water and light grasses. Do not overdo it as you cannot paint over a scratched-out area.

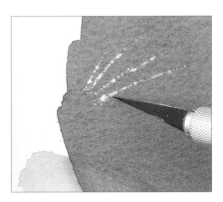

Simply scratch the surface of the paper with the tip of your craft knife. Be careful not to use too much force, or you will cut through the paper completely and ruin your work.

Washes

Before you start to paint, prepare your materials carefully. Water your paints down to the consistency of milk and prop your board up to about 20–25 degrees from horizontal. The colour should move languidly, and form a 'bead' of paint at the bottom.

FLAT WASH (WET ON DRY)

1 Run masking tape down the edges to give a nice crisp border to the finished piece.

2 Load your brush with paint, and draw the bead of colour back and forth with steady horizontal brushstrokes.

3 Do not scrub with the brush, but pull the bead of paint smoothly to ensure an even coat of colour. Reload the brush when the paint runs low.

4 When you reach the end of the paper, use a dry brush to lift off any excess paint.

5 Allow to dry, and remove the masking tape. You should have a flat area of colour.

TIP

This technique has been painted with wet paint on to dry paper (a technique known as wet on dry), but for larger areas, wet your paper with a wash of clean water first, and paint wet in wet to avoid lines where the paint overlaps.

VARIEGATED WASH (WET IN WET)

1 Mask your paper as before, and use a brush loaded with clean water to wet your paper until a gloss forms.

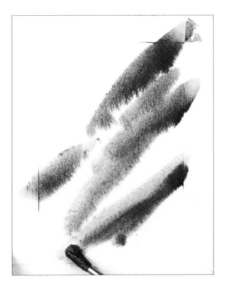

2 Add in your first colour and allow it to spread and feather.

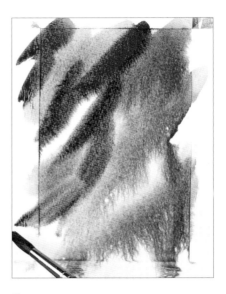

3 While the paper is still wet, add your second colour and watch as it bleeds and blends into the first.

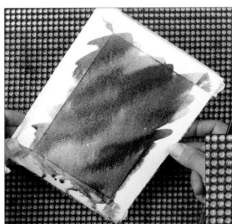

4 You can tilt your paper as shown to help soften the colours.

TIP

This wet in wet technique can lead to backruns if you add wet paint to a damp wash. You cannot add more water once you have added paint, so wet the paper correctly before you start adding paint. Remember: damp is dangerous!

5 Continue tipping the paper until you are happy with how the colours look, and lay it flat to dry.

6 Remove the masking tape. Note how the colours blend smoothly into one another, with no hard lines.

GRADATED WASH (WET ON DRY)

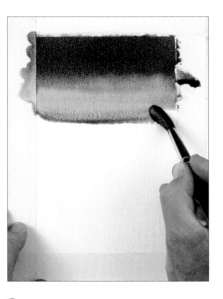

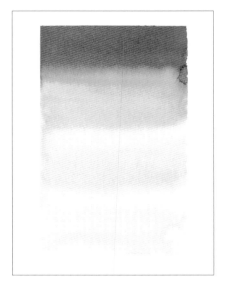

1 Mask your paper, and lay in the paint until a bead forms. Using steady horizontal brushstrokes, draw the bead back and forth.

2 Instead of adding more paint when your brush runs low, add clean water. The paint will start to fade as you work downwards.

3 Allow to dry, and remove the masking tape. Note how the paint forms a smooth gradient of colour when dry.

EXPLOSIVE WASH (WET IN WET)

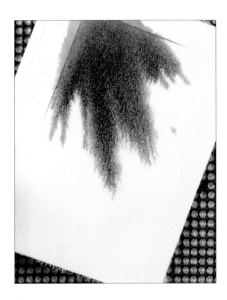

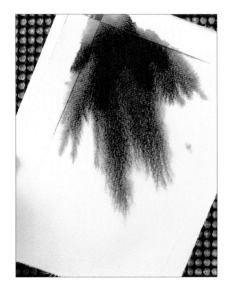

1 Mask your paper and wash it with clean water until a sheen or gloss forms. Tilt your paper and add your paint with sharp movements. The paint will begin to feather as shown.

2 Add more paint at the base of the area of colour to strengthen it. Move the paint by tilting the paper, not using the brush.

3 Once the paint has dried, remove the masking tape. Note that different papers will give different effects.

Mixing and matching (wet on dry and wet in wet)

1 Wet your paper and paint a gradated wash as shown. Allow the paint to dry completely.

2 Turn the paper upside-down and lay in a little water (not so much as before). Lay in your second colour and allow it to bleed in to the water.

3 Add a little extra paint to add interest, then tilt the paper to meld and merge the colours.

4 Allow the paint to dry and remove the masking tape.

Clearing Skies

I painted this small picture using a variety of the techniques covered in this chapter. See if you can recognise which ones I have used and how they hang together to make a picture.

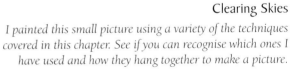

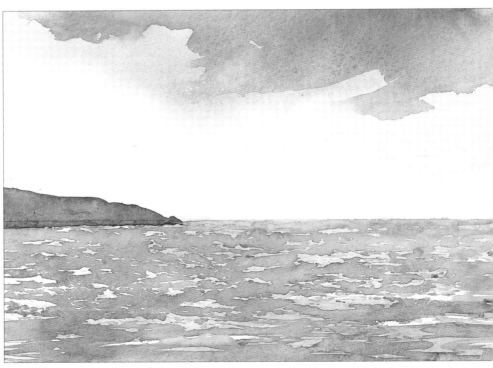

Using colour

At the risk of repeating myself, it really is most important to keep your colours clean, keep them vibrant and keep them wet. Most of all, do not overmix them!

COLOUR EXERCISE 1

This is a colour mixing exercise I do to get people loosened up and to show how paints and colours interact dynamically. It also shows that with just three primary colours you can obtain a multitude of different colour mixes.

1 Prepare pure yellow, alizarin crimson and French ultramarine. Use a size 8 brush to spatter and paint swirls of yellow.

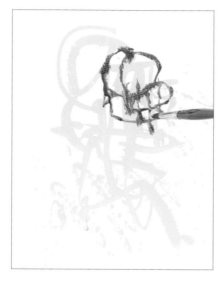

2 Paint swirls of alizarin crimson over and around the yellow wet in wet. Notice the oranges that begin to appear where the colours bleed into each other.

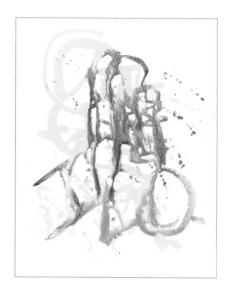

3 Continue adding swirls of crimson, then spatter it over the paper. Allow the colours to bleed and interact with one another.

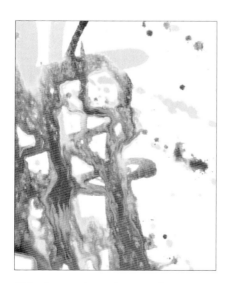

This close-up shows the two colours mixing into one another.

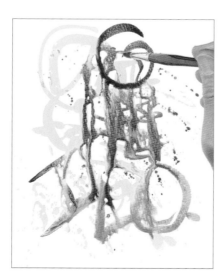

4 Begin to add swirls of French ultramarine to the colours.

5 Develop the swirls of blue and spatter more in wet in wet.

6 Notice the darker-toned greens, browns and purples that start to appear as you develop the blue swirls.

7 Lift the entire painting off the board and tilt it back and forth to mix the beads of colour.

8 Put the board down and spatter all three colours over the wet paint, one after the other.

TIP

These darker tones are sometimes referred to simply as 'darks'.

9 Allow the painting to dry completely.

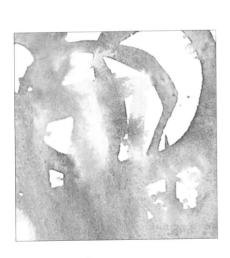

This close-up shows some wonderful purples, oranges and bright, vibrant greens.

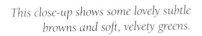

This close-up shows some lovely subtle browns and soft, velvety greens.

COLOUR EXERCISE 2: WASDALE HEAD, CUMBRIA

Before we do a full-scale project, this is a simple exercise to get you started on your way to painting creative washes successfully. I have deliberately kept it simple so you can follow the steps and get used to using a variety of the techniques explained earlier.

This is a good chance to practise laying down exciting, vibrant watercolour and will give a good basis for the later projects.

YOU WILL NEED

640gsm (300lb) mould-made watercolour board, 40 x 30cm (16 x 12in)
2B pencil
Masking tape
White gouache
Brushes:
Size 12 round, size 3 rigger
Watercolour paints:
Pure yellow, cobalt blue, rose madder, brown madder and manganese violet

1 Use a 2B pencil to sketch the outline as shown. Mask the edges with masking tape, and prepare wells of pure yellow, cobalt blue and rose madder.

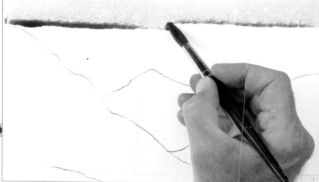

2 Lay a flat wash of cobalt blue in the top half of the sky, using the size 12 brush.

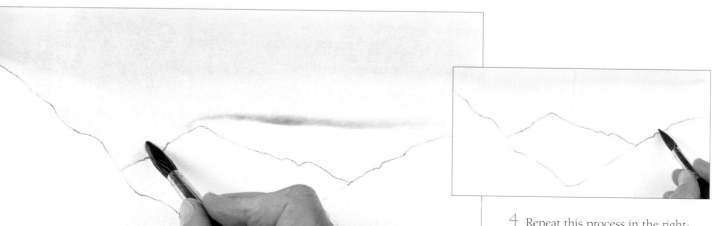

3 Use clean water to draw the bead of cobalt blue down, gradating the colour into the left-hand valley.

4 Repeat this process in the right-hand valley and allow to dry.

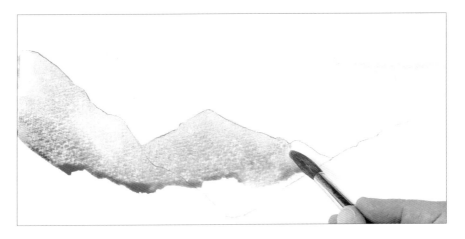

5 Use the dip dip dip technique with cobalt blue and pure yellow, and begin to paint the hills, starting from the top – remember to dip the brush quickly! Notice the rich greens that are produced. Introduce rose madder on the left.

6 Continue working down the hills, producing a variegated wash as shown by adding cobalt blue in the centre and rose madder on the right.

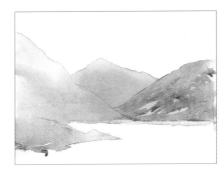

7 Still using the dip dip dip technique to ensure variation in the colours, complete the hills. Notice how the paints blend more as you get to the bottom of the picture, producing even more colours.

8 When the paint is dry, prepare brown madder and make a variegated glaze over the right-hand hill, using all four colours. A glaze is simply a very thin wash over an area that has already been painted.

TIP

The colours of objects fade as they recede into the distance, and get stronger as they advance. You can simulate this in paintings by using stronger mixes for closer objects.

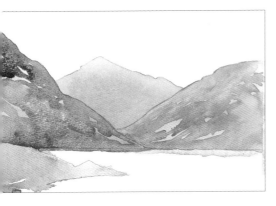

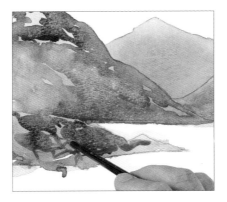

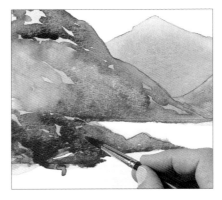

9 Prepare manganese violet and lay a variegated glaze of all five colours over the left-hand hill. The reds and yellows give warm tones, the blue and purple cool tones, and the brown gives neutral tones.

10 Repeat this process on the beach area at the front, using the cool blue and purple tones, then use the end of the brush to pull the paint around and create texture.

11 Add more cobalt blue to the area to strengthen the beach, and allow to dry thoroughly.

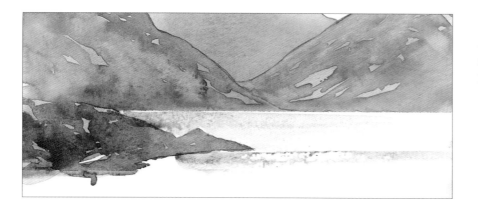

12 Paint in the water at the front of the picture with broad horizontal strokes, using cobalt blue with some pure yellow.

13 Continue until the area is almost filled, and drop in some touches of manganese violet wet in wet. Allow to dry thoroughly.

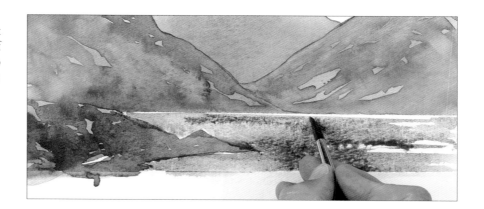

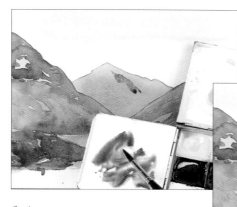

14 Add texture to the background hill with a palette mix of cobalt blue and rose madder.

15 Use cobalt blue to add deeper texture to the background hill. Cool colours appear to recede, helping give the painting depth.

16 Lift out the edges of the right-hand hill using clean water. This creates texture by highlighting ridges on the hill.

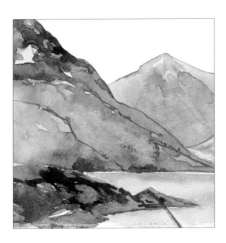

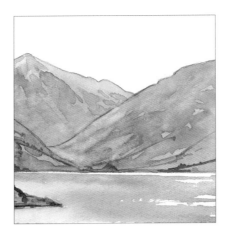

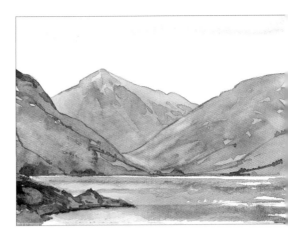

17 Switch to the rigger brush, and add texture and detail to the left-hand hill and beach, using a neutral grey mix of cobalt blue, brown madder and manganese violet.

18 Using the size 12 brush, paint a pure yellow glaze over the lifted-out areas of the right-hand hill.

19 Use the dry brush technique with cobalt blue and manganese violet to draw horizontal strokes across the water on the right.

Wasdale Head, Cumbria
40 x 30cm (16 x 12in)
Add some white gouache spots and streaks with the rigger for the finishing touches.

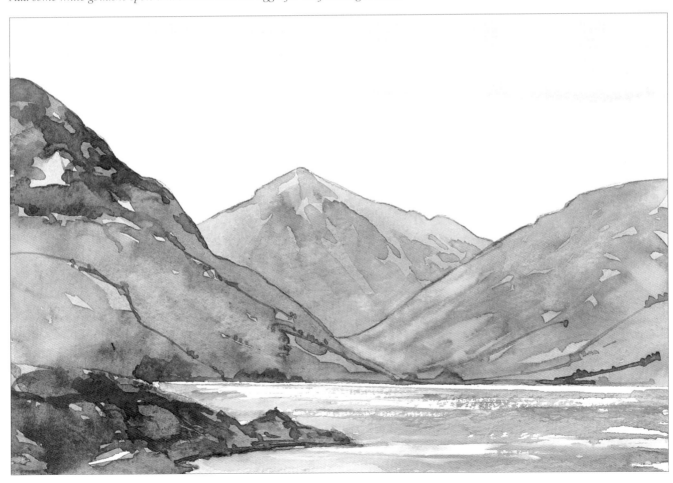

Using a sketchbook

Painting *en plein air* is an absolute delight and a must for the development of the landscape artist. You really get to feel at one with the subject, and because the weather can change so rapidly it forces you to seize the moment and stops you fiddling. This is a great way to loosen up, ensuring you end up with a fresh painting.

When working outside, a quick tonal sketch using ink and water is an ideal way to prepare for a painting. The tonal sketch will help you work out the areas of light and shadow without the added complication of colour.

A selection of the hardbound watercolour sketchbooks which are my travel journals. I take A4 and A3 format sketchbooks wherever I go.

These quick black and white tonal ink sketches demonstrate the importance of having a tonal plan before you start with colour.

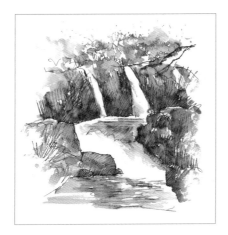

This is a quick tonal ink sketch of the 'Secret Waterfalls' in Snowdonia, and a quick colour sketch I made using watercolour pencils.

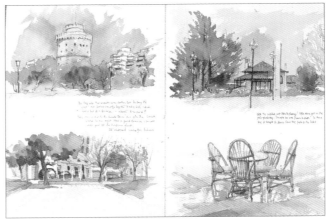

A series of four small watercolour studies done in my A3 sketchbook whilst on a painting break in Halkidiki, Greece. I love doing smaller sketches on a large piece of paper as I have loads of space to move around – and lots of white paper!

Two double-page panoramas in my A3 sketchbook of the village of Urchfont, Wiltshire.

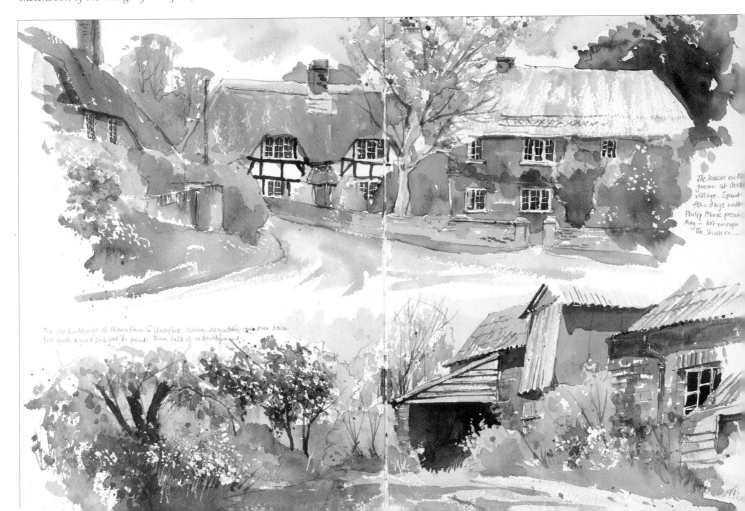

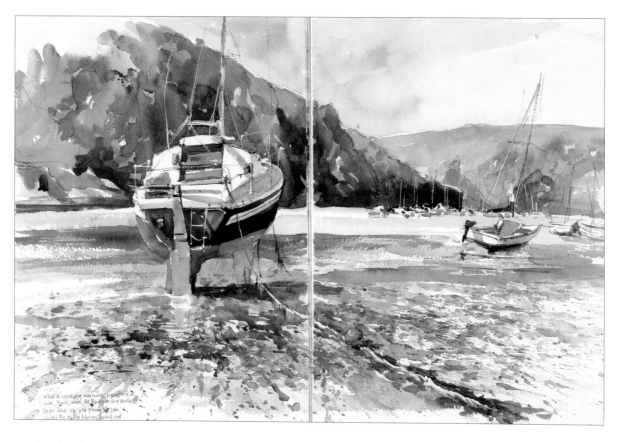

Another double-page spread from my A3 sketchbook. This was a really hot day down at the small harbour of Solva in Pembrokeshire. I set myself up on the mud as the tide was receding. By the time I finished the tide had gone right out.

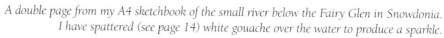

A double page from my A4 sketchbook of the small river below the Fairy Glen in Snowdonia. I have spattered (see page 14) white gouache over the water to produce a sparkle.

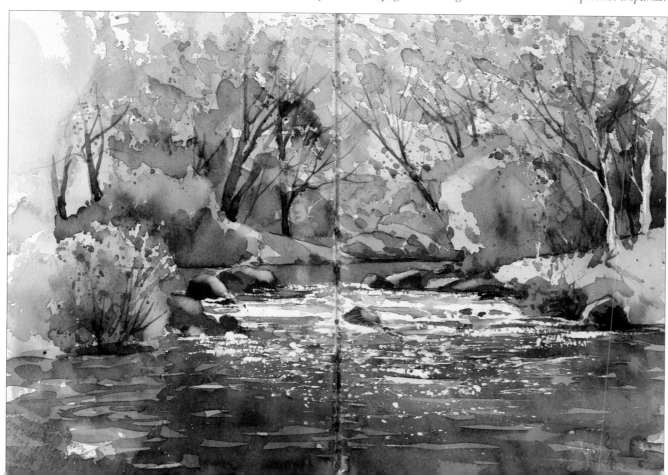

New England in the autumn is a sight to behold. The colours really knock you out, so I was keen to get the essence of this small inlet into Lake Pauline, Vermont, before the sun moved round. I love the way the sharp light on the foreground foliage contrasts with the background water. This is from my A4 sketchbook.

Sunset over Garway Hill

What better subject to start with than the view from my front garden? I look out across the Hereford vale towards the Black Mountains in Wales, and the profile of Garway Hill is the most prominent feature on the skyline.

There have been some really dramatic sunsets over the hill, and I never tire of trying to capture the transient light as the sun sets behind it.

This is a good project with which to start as there are lots of loose watercolour washes and not too much detail.

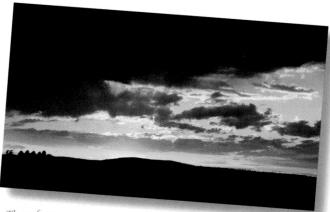

The reference photograph for this painting.

The preliminary sketch.

The finished painting.

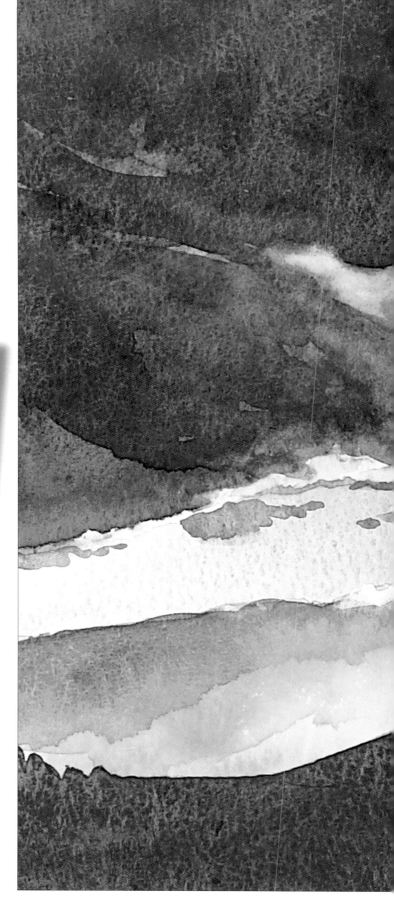

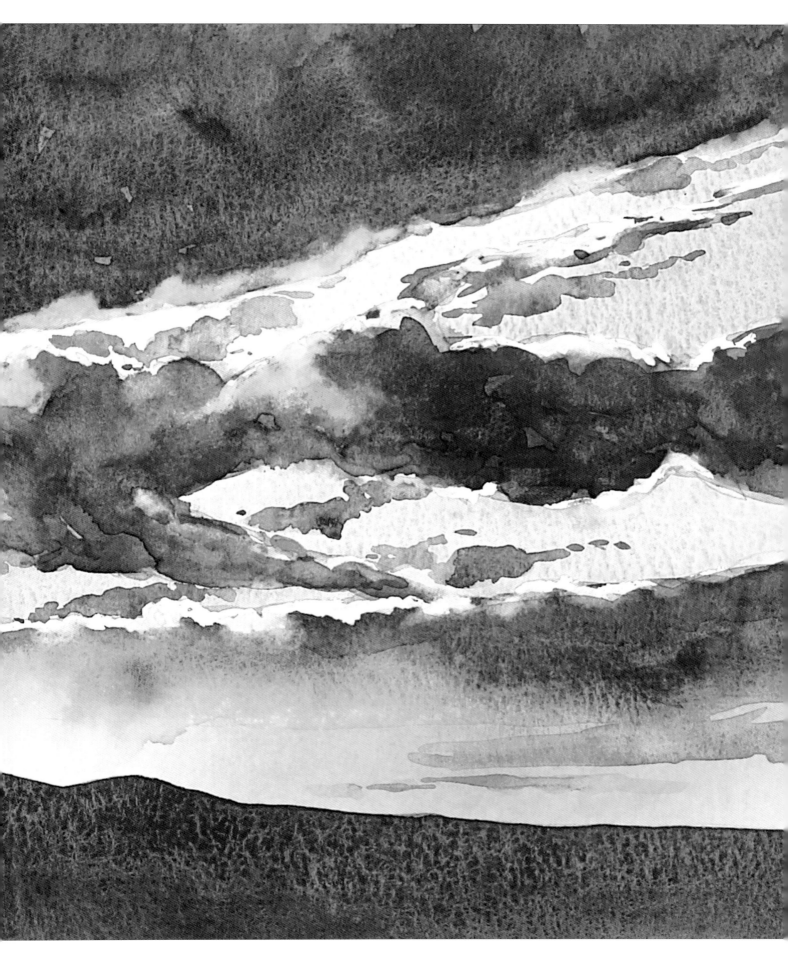

1 Run masking tape down the edges of the paper, then use a 2B pencil to sketch the outline of the hills and clouds, then tint your masking fluid with rose madder and apply it as shown above. Allow to dry, then prepare cobalt turquoise, cobalt blue and rose madder.

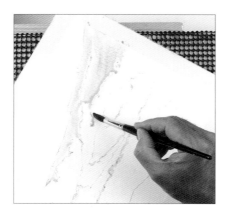

2 Work from left to right to wet a rough triangle in the top right. Drop in cobalt turquoise with the size 12 brush, and work it across the wet area, using the top of the brush to keep it moving. Tilt the board and use horizontal brushstrokes.

3 Add cobalt blue wet in wet to the triangle, and allow it to bleed into the cobalt turquoise to strengthen the colour of the sky area.

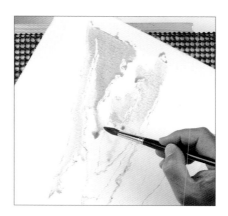

TIP

The next few steps rely on the sky being absolutely bone dry, so do not proceed until you are confident that they are completely dry.

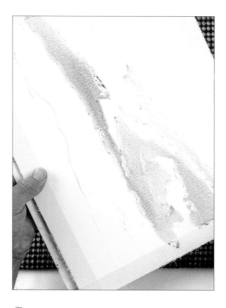

4 Add rose madder wet in wet on the left-hand side of the painting, and draw the paint from the triangle across the entire picture.

5 Tilt the board back and forth to mix the colour thoroughly, and to ensure that pools of paint do not have a chance to form. Allow to dry.

6 Turn the board upside-down and wet the foreground (at the top of the picture here). Add pure yellow wet in wet, and allow it to spread.

7 Keeping the board upside-down, add rose madder to the foreground wet in wet.

8 Add a stronger mix of rose madder at the edge of the foreground, again allowing it to bleed into the rest of the foreground area.

9 Feed manganese violet into the stronger rose madder area and draw it out across the horizon line as shown.

10 Tilt the board towards you to feed the colours into one another and form a darker band at the horizon.

11 Do not allow the colours to dry patchily on the horizon. Keep the paint moving from one side of the painting to the other by tilting it slowly back and forth, allowing the paint to flow and dry smoothly.

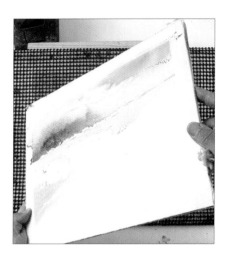

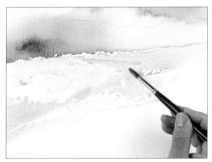

12 Still working upside-down, wet the space in the central triangle, and drop in pure yellow wet in wet.

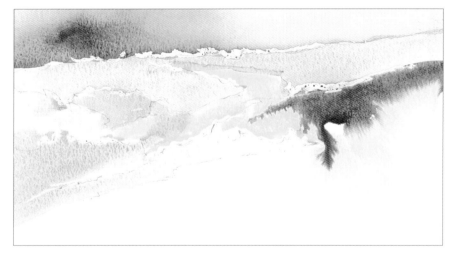

13 Develop the yellow area, expanding it to fill almost all of the white space in the middle of the paper, then add rose madder wet in wet.

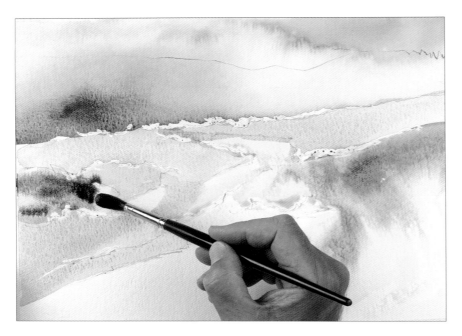

14 Continue adding pure yellow right to the top of the sky (the bottom of this picture), then introduce more rose madder on the left.

15 Tilt the board and continue dropping in small amounts of rose madder and pure yellow as you continue to fill the sky.

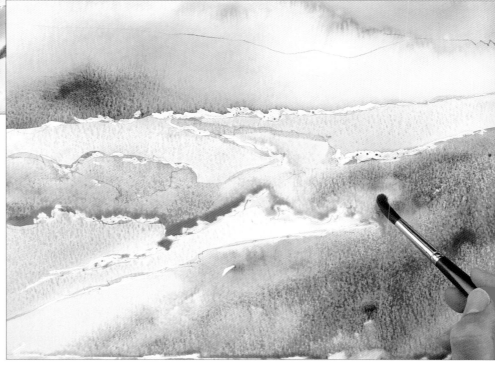

16 Darken the sky by adding strokes of manganese violet into the yellow and rose.

17 Use light strokes of the brush to move and blend the colours without muddying them, until the entire sky is covered.

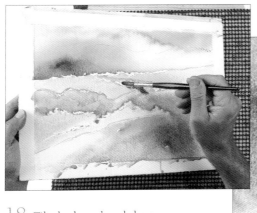

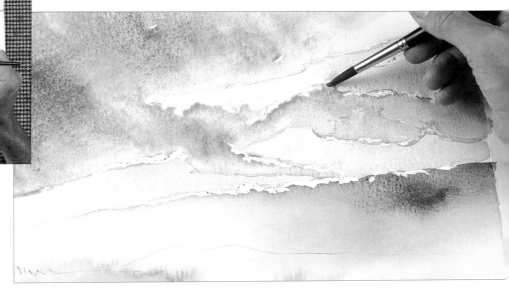

18 Tilt the board and drop in patches of rose madder to add interest.

19 Turn the board the right way up, and tickle the edges of the clouds to ensure that they look lit from beneath, adding darker areas at the top of the clouds.

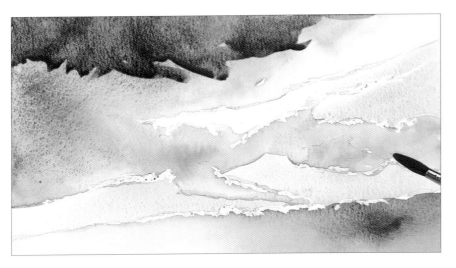

20 Use the dip dip dip technique (see page 14 for details) with cobalt blue, brown madder and manganese violet for the darker areas of the clouds.

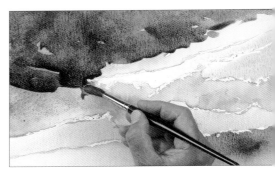

21 Draw the colours down the large cloud, and keep them moving. Make sure you leave a border of the lighter colours at the bottom of the cloud.

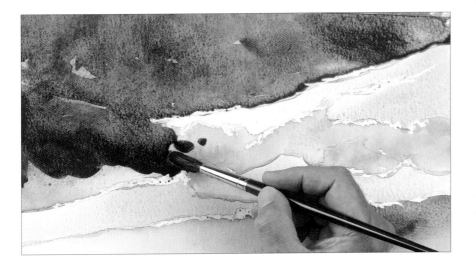

22 Introduce warmer tones over the lighter borders and towards the bottom of the cloud with rose madder. Then begin to draw the darker colours into the top of the central area of cloud as shown.

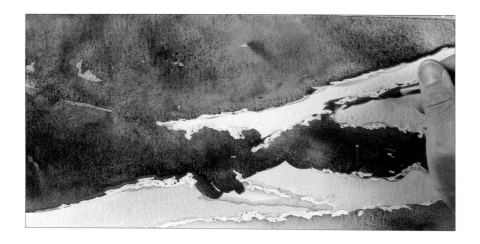

23 Continue adding these darker tones of brown madder and rose madder, working carefully into the central area of cloud.

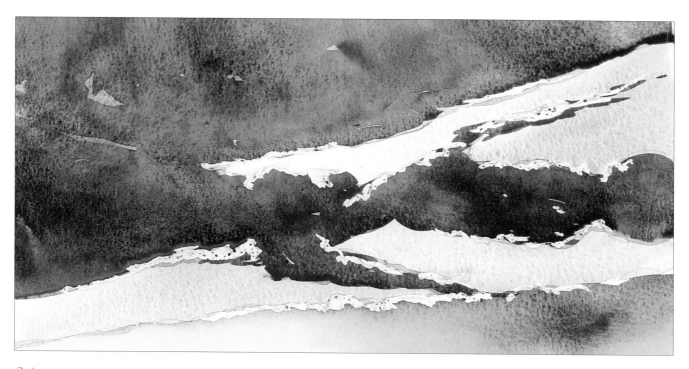

24 Work right down to the bottom of the cloud in the centre of the painting. You are aiming to cover but not obscure the colours underneath with these darker tones. This will add mood and atmosphere.

25 Wet the cloud beneath the central cloud, and drop in pure yellow to the wet area, drawing it across the top of the lower cloud.

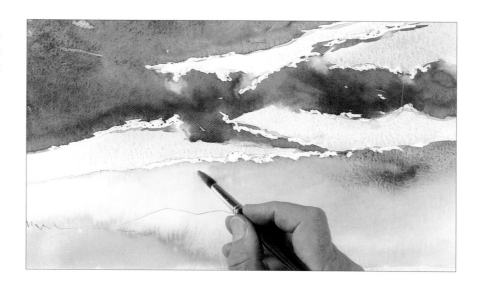

TIP

It is transparency that gives this painting luminosity and freshness, allowing the colours underneath to show through the colours above, so do not make your mixes too heavy.

26 Introduce manganese violet wet in wet to the yellow area, encouraging the two colours to bleed into one another with the tip of the brush.

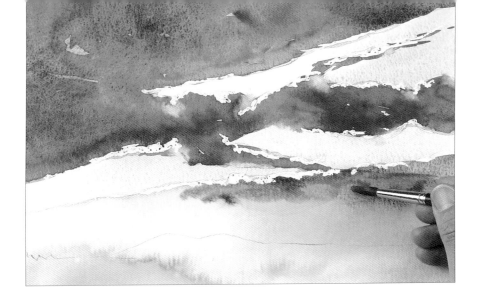

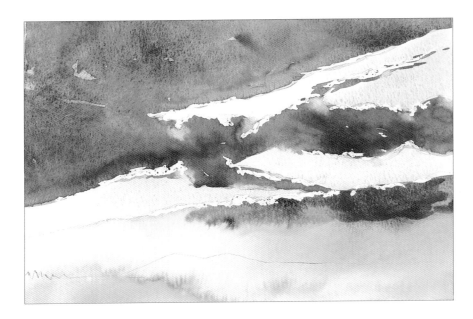

27 Add a little brown madder to the mixes and paint darker tones on the right of the wet area.

28 Keeping the paper wet, paint warm, soft tones of pure yellow and manganese violet to the left.

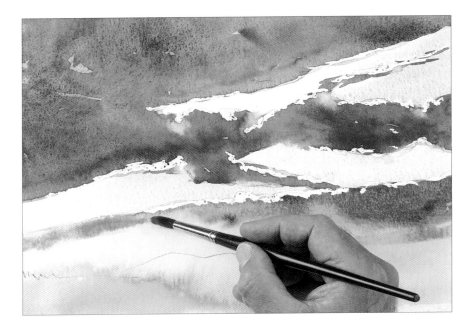

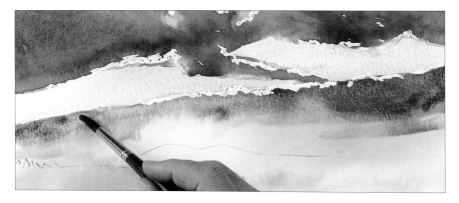

29 Add darker tones of cobalt blue, brown madder and manganese violet on the left of the bright area. Having the darker areas at the sides of the painting stops the eye wandering off the page, and makes the bright centre the focal point.

30 Wet your size 8 brush with clean water and roll it across the light area to lift out some of the pigment.

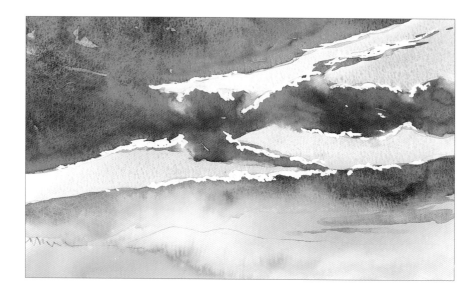

31 Allow the entire painting to dry thoroughly, and then rub off all of the masking fluid to leave clean white spaces with sharp edges as shown.

Tip

With watercolour, once you have painted over the white of the paper, you can never bring it back. Be careful and work out where you want the finished painting to remain white.

32 Wet your hog brush and use it to soften the edges of the newly-revealed white areas, drawing a little of the pigment around them into the clean space.

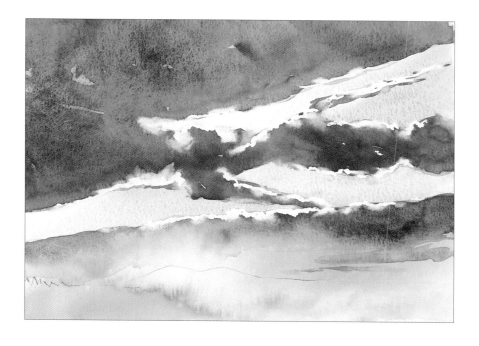

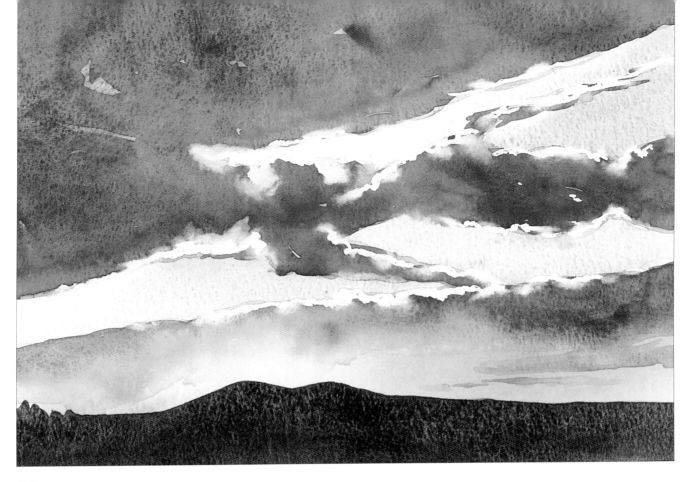

33 Using the size 12 brush, place a flat wash of cobalt blue and manganese violet to form a silhouette of the hills across the bottom of the painting.

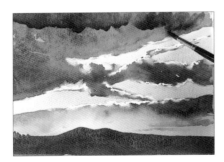

34 Still using the size 12 brush, glaze darker tones of cobalt blue, manganese violet and brown madder into the top cloud.

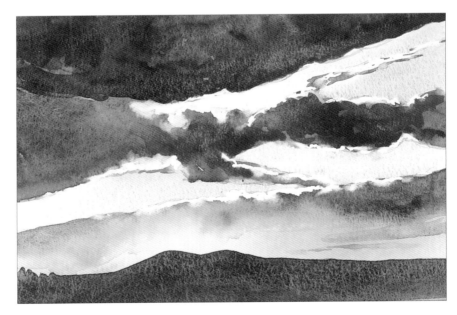

35 Glaze these warmer dark tones over the whole of the top cloud. In conjunction with the darker clouds to the edge of the painting and the silhouetted hills at the bottom, this produces a frame effect that draws the eye to the bright, warm sunlight at the centre of the painting.

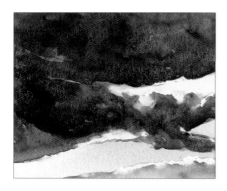

36 Add warm, dark tones to the left of the central clouds.

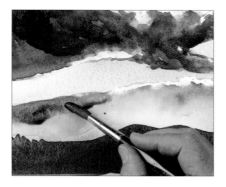

37 Use thinned rose madder and manganese violet to vary the left side of the bright cloud.

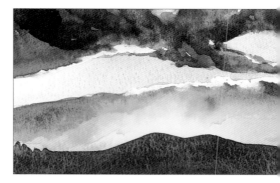

38 Roll a damp size 8 brush across this area to lift out excess paint and soften the transition of colour.

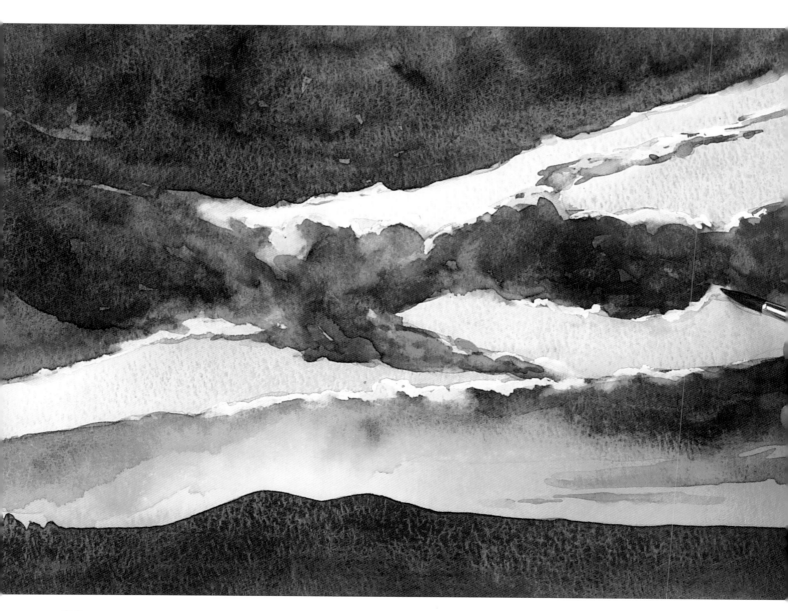

39 Use the size 8 brush and pure yellow to paint some of the white areas left by the masking fluid.

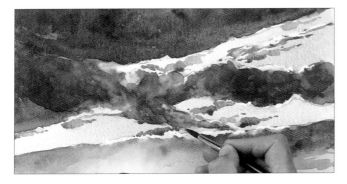

40 Use Indian yellow and brown madder with rose madder to suggest smaller clouds in the blue sky around the main clouds.

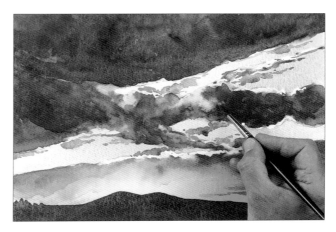

41 Wet the top of the central cloud with a size 8 brush, and use kitchen paper to lift out a light area, before dropping in pure yellow.

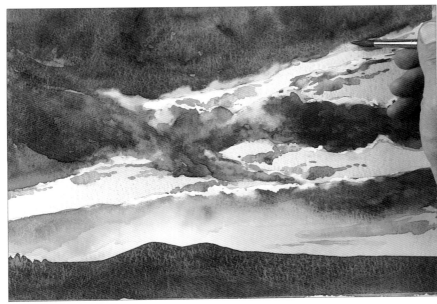

42 Repeat this process around the centre of the painting, giving the impression of the sun shining through the break in the clouds. This will lift the whole painting.

43 Allow the painting to dry thoroughly before removing the masking tape.

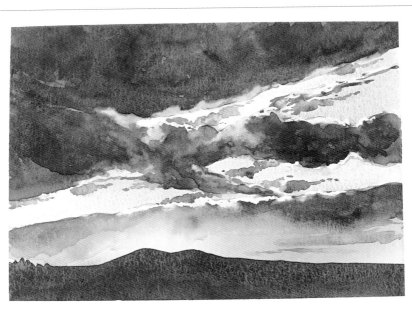

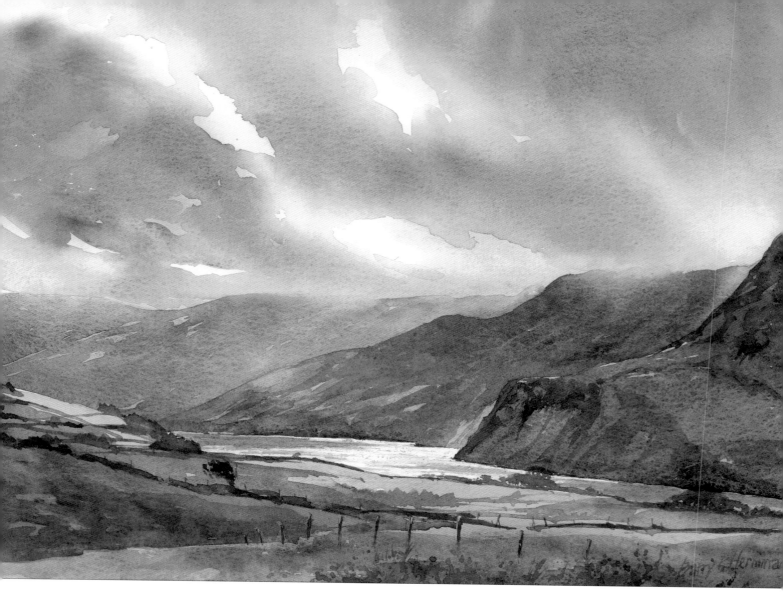

Rain over Ennerdale

48 x 36cm (19 x 14in)

Here at Ennerdale, the rain clouds come racing in across the fells from the west, bringing in a lot of wet weather. However, they also bring some fantastic light patterns, and in this example, they lit up the water. This is the view from a small village above Ennerdale where I was staying during a workshop in Cumbria.

Opposite:
Over the Fells

48 x 36cm (19 x 14in)
This picture was painted for a workshop to show how to build up distance using a succession of glazes. Notice how much stronger and more detailed the foreground is compared with the background hills.

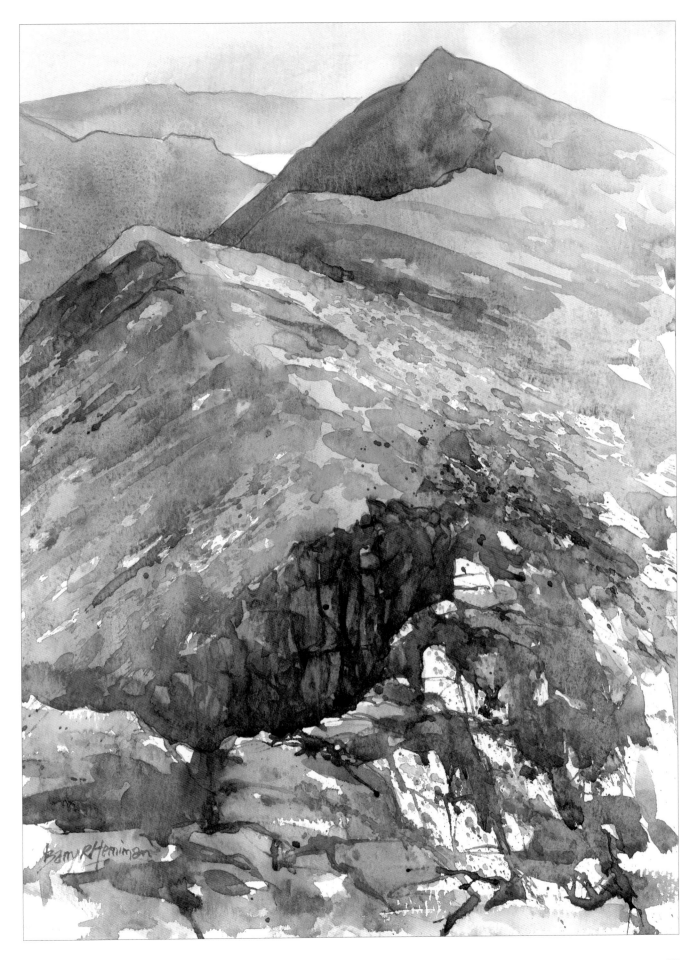

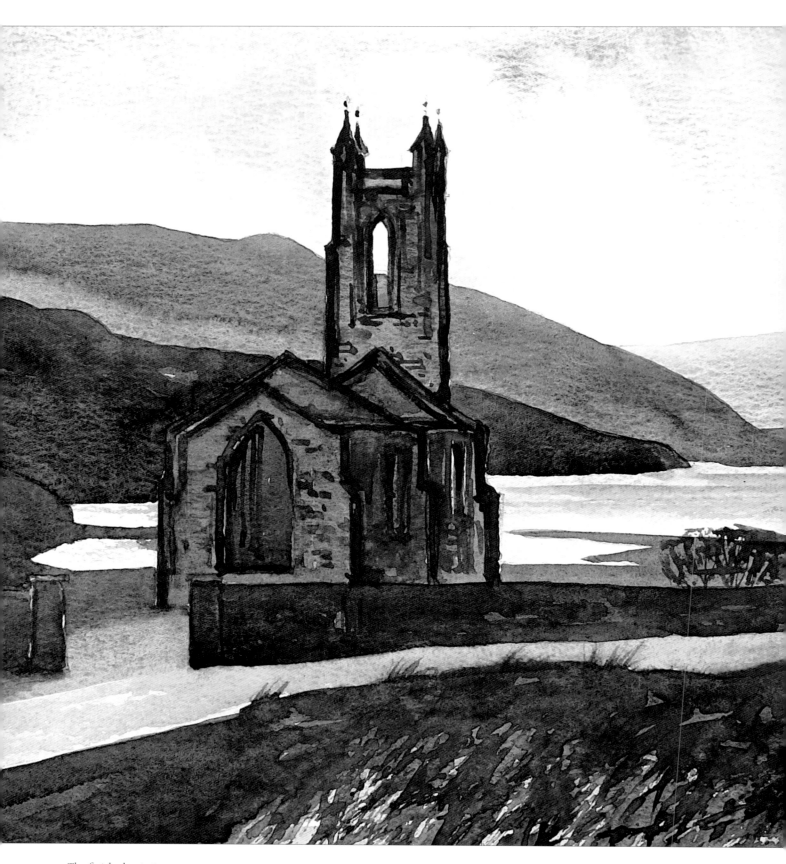

The finished painting.

The Old Church at the Poison Glen

This church stands at the head of Lough Nacung in the valley below the Poison Glen in Scotland. Today it is only a shell as a fire took out all the roof timbers, and now only the tower and walls remain. It still makes a very impressive landmark, with its light-coloured stone walls and dark cornerstones. As you drop down into the glen from the top road to Dunlewy, the tall perpendicular tower starts to loom large in front of you.

This view is from behind the church, looking down into the lough with the Poison Glen behind us. The afternoon sun was in front of me, which makes the church and the background hills stand out in sharp relief against the sky and the lough.

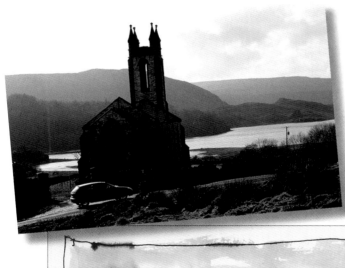

The reference photograph for this painting.

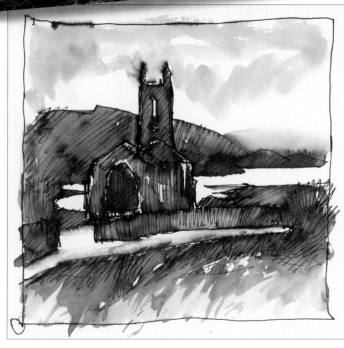

The preliminary sketch.

TIP

These first few stages are worked
fairly quickly, so make sure that you
lay in enough water to ensure that
the painting remains wet.

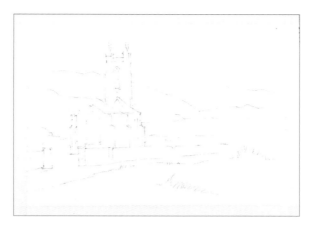

1 Apply masking
tape to the edges of
the picture, then use
a 2B pencil to sketch
out the basic shapes
of the church, the
wall, the foreground
grasses and the hills.

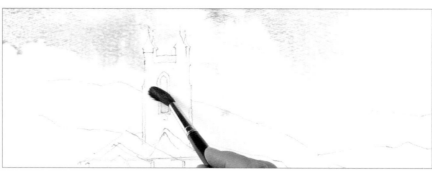

2 Wet the whole picture with a size 16 round brush and use a size 12 brush to add
a variegated wash of cobalt turquoise and manganese violet. Tilt the picture to help
the paint to flow, and leave some gaps in the wash.

3 Wash in the distant hills with
a flat wash of rose madder and
manganese violet. Paint right across
the church tower.

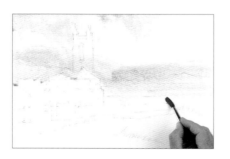

4 Still working wet in wet, use cobalt
turquoise to paint in the hill in the
middle distance.

5 With the same colours used on the
hills, lay in a variegated wash on the
church tower.

6 Still using the same colours and
brush, lay a variegated wash across the
lower half of the picture.

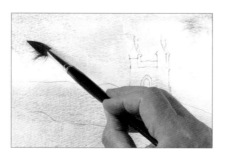

7 Before the painting dries, remove
any pools of paint that have formed.
Roll a dry brush across the painting to
draw up excess paint.

NOTE

As a point of interest, the singer
Enya filmed one of her music videos
at this very spot.

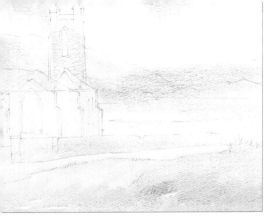

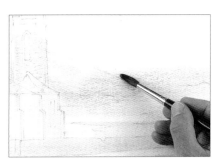

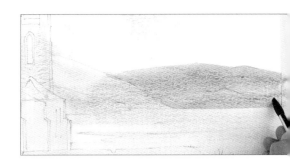

8 Use the hog brush to lift out details in the foreground grasses, along the path and on the edges of the church. Allow the painting to dry thoroughly before continuing.

9 Use the size 12 brush to lay clean water in between the two hills in the middle distance.

10 Using the dip dip dip method with cobalt turquoise, rose madder and cobalt blue, paint the hill on the right-hand side.

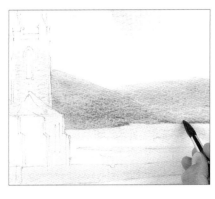

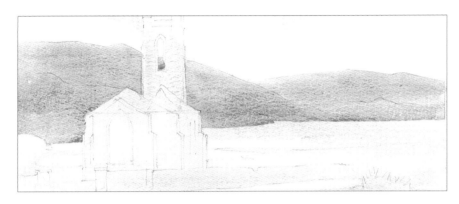

11 Paint the second hill with the same colours. Use a slightly stronger set of mixes to create contrast between the hills.

12 Following the crest of the hill, fill in the lower half of the church window with the same mix, then complete the hill by painting in the part on the left of the church tower.

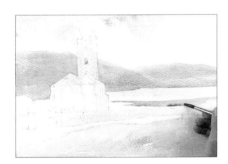

13 Prepare washes of cobalt blue, raw sienna and rose madder, and use the dip dip dip method to add a touch of colour to the ground above the wall of the churchyard.

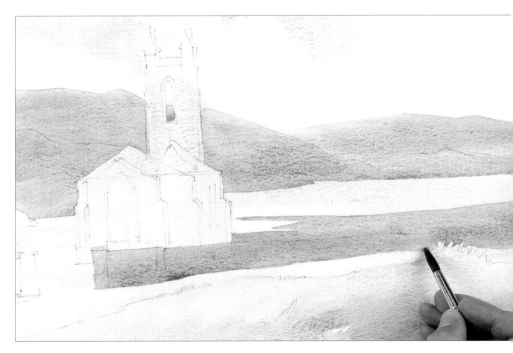

14 Continue painting in the churchyard wall with these colours, and add mixes of Indian yellow and cobalt turquoise as you advance.

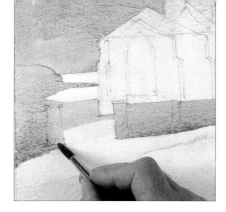

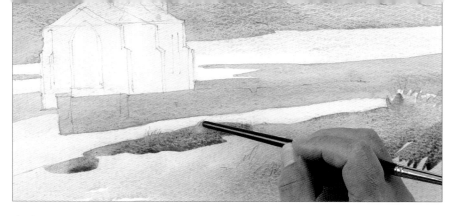

15 Use the same colours to paint the ground to the left of the church. Mix the colours a little more thoroughly to give a slightly grey feel.

16 Make up Indian yellow, manganese violet and more rose madder, and paint in the foreground grasses with the dip dip dip technique. While wet, use the end of the brush to draw out longer grasses with quick upwards strokes.

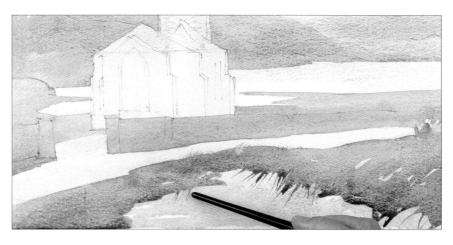

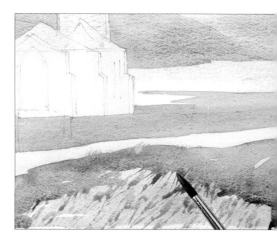

17 Develop and vary the entire foreground with these colours and the dip dip dip technique. The slightly stronger mixes help give the paler background colours a mist-shrouded look.

18 Spatter Indian yellow into the lighter area in the central foreground.

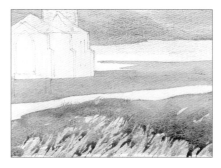

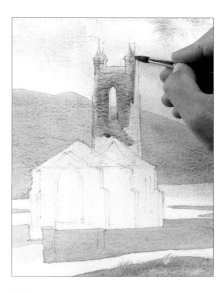

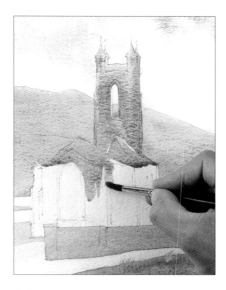

19 Spatter manganese violet into this same area, and allow the colours to bleed into one another.

20 Switch to the size 8 brush and paint a variegated wash of cobalt blue and manganese violet across the church tower.

21 Introduce Indian yellow to the variegated wash to paint the tops of the church walls.

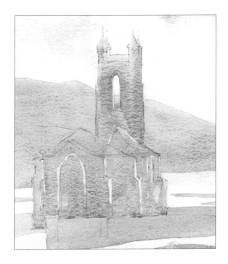

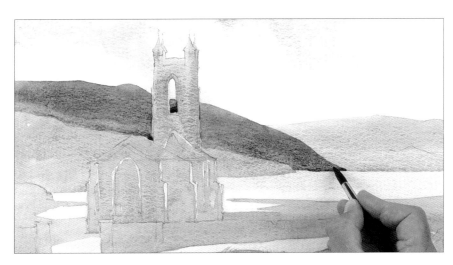

22 Continue the variegated wash of cobalt blue and manganese violet over the bottom of the walls. Keep the colours moving to stop darker areas appearing dull.

23 Give your mixes of cobalt blue and manganese violet a little more body and substance by adding more paint to them, then prepare brown madder. This will add sharpness to the painting. Paint a gradated wash from dark to light on the hill behind the church. Use the dip dip dip technique with these three colours.

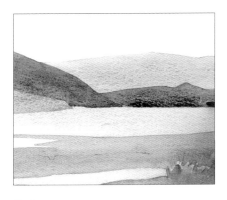

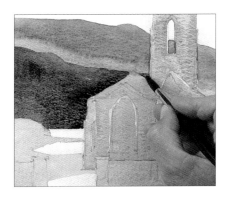

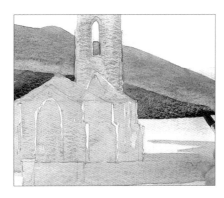

24 Use the same mixes and technique to paint a gradated wash on the right-hand hill.

25 Paint the hill immediately behind the church with a flat wash made up of cobalt blue, brown madder and manganese violet.

26 Continue the flat wash on the other side of the church, right down to the water's edge.

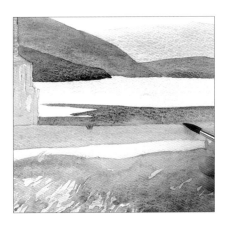

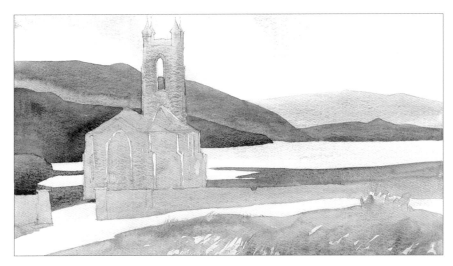

27 Begin to paint a warm variegated wash of Indian yellow, manganese violet and brown madder on the foreground area by the lake.

28 Making sure that you do not paint the wash into the churchyard wall, continue the warm variegated wash across the lake's edge.

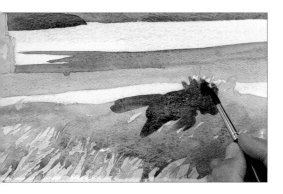

29 Warm the extreme foreground with a variegated wash using still stronger mixes of the same colours.

30 Use the end of the brush to pull out grasses and suggest a scrubby texture to the heath as you go.

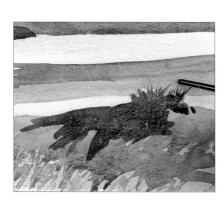

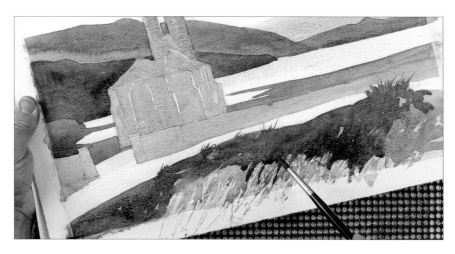

31 Continue this process across the whole of the foreground, warming and reinforcing the scrubland feel. Leave a lighter patch in the centre and spatter Indian yellow into this area, followed by cobalt blue. Tilt the painting and gently tease the colours together to blend them together.

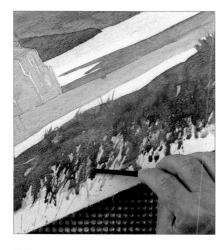

32 Still concentrating on this area, spatter rose madder, and use the end of the brush with quick upwards strokes to further blend the colours.

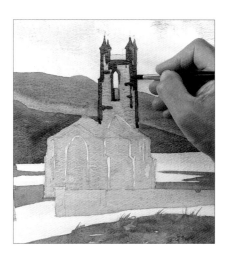

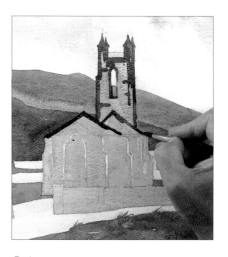

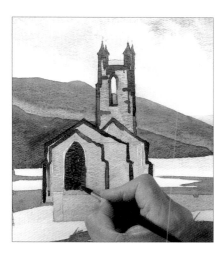

33 Prepare strong mixes of French ultramarine, manganese violet and brown madder. Use these with the size 8 brush to outline and detail the church tower.

34 Use more brown madder when outlining the tops of the walls. Using a size 8 brush gives you more control, allowing you to keep the edges of the building sharp.

35 Continue detailing the church walls, painting in the buttresses of the walls and the large window at the front of the church.

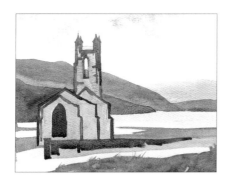

36 Still using the size 8 brush, paint in the top of the wall beside the church. Use a little more brown madder to make it appear warmer than the church itself.

37 At the right-hand end of the wall, paint some low trees. Use the same colours as the wall with the dry brush technique. Lay the brush down sideways on the paper and jerk it down to create a broken foliage effect.

39 Paint the small section of wall on the left-hand side of the painting with the same colours and brush.

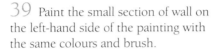

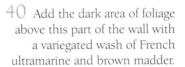

40 Add the dark area of foliage above this part of the wall with a variegated wash of French ultramarine and brown madder.

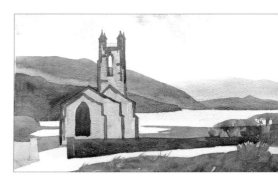

38 With the trees in place, go back and paint the bottom of the wall, using slightly more French ultramarine than you used for the top.

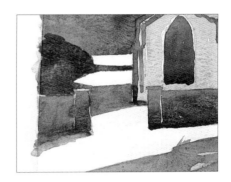

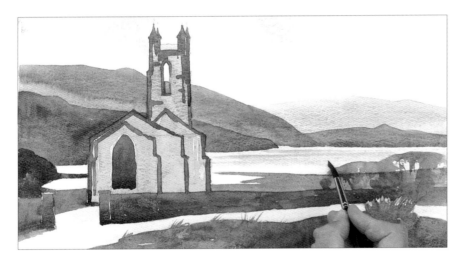

41 Use a thin gradated wash of rose madder and manganese violet to paint in the lake.

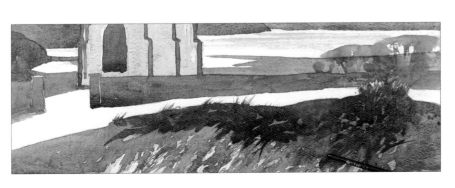

42 Begin to work darks into the foreground, using small variegated washes and spattering.

43 Continue working across the bottom of the picture, spattering manganese violet wet in wet, and creating texture by using the end of the brush.

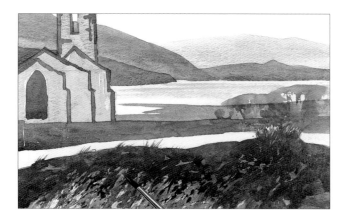

44 Spatter Indian yellow into the light patch, and encourage the colours to bleed into each other with light strokes of the tip of the brush.

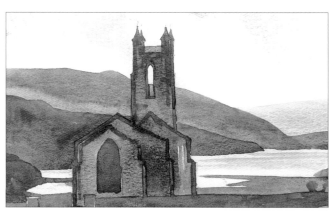

45 Paint a thin variegated wash of cobalt blue, cobalt turquoise and manganese violet across the whole church to unify the colours.

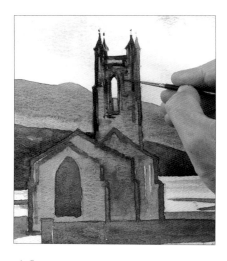

46 Detail the church tower with the rigger and strong mixes of cobalt turquoise and manganese violet.

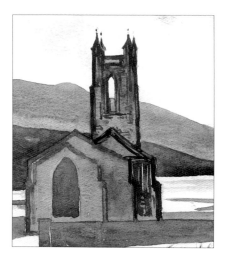

47 Continue detailing the church with these colours and the rigger, working right down the sides of the main body of the church.

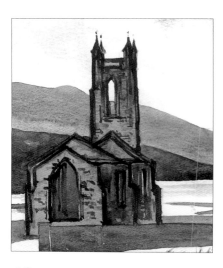

48 Add bricks and reinforce the outline at the front of the church with the rigger and the same colours.

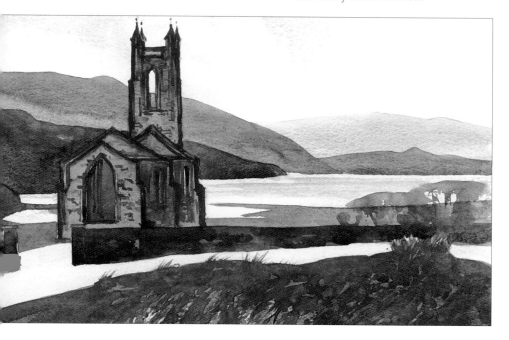

49 Strengthen the wall with a glaze of cobalt blue and manganese violet warmed slightly with the addition of rose madder.

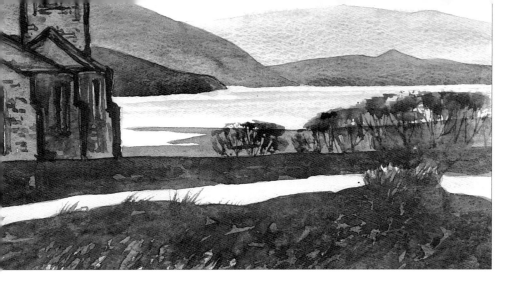

50 Use the dry brush technique with the rigger to add more bushes behind the wall, using rose madder to warm manganese violet.

51 Use the rigger to add detail to the trees, then switch to the size 12 brush and lay in a very thin flat glaze of manganese violet and rose madder across the path and on the church building itself.

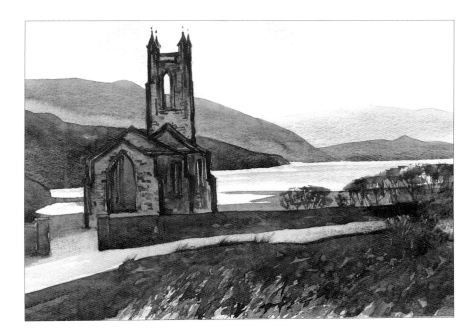

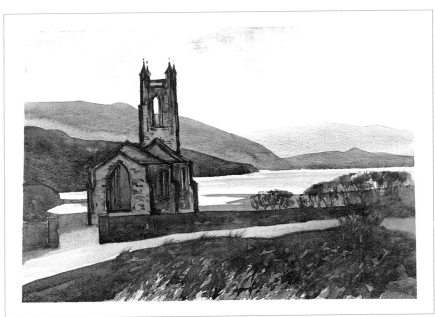

52 Allow the painting to dry thoroughly, and then remove the masking tape from the edges to finish.

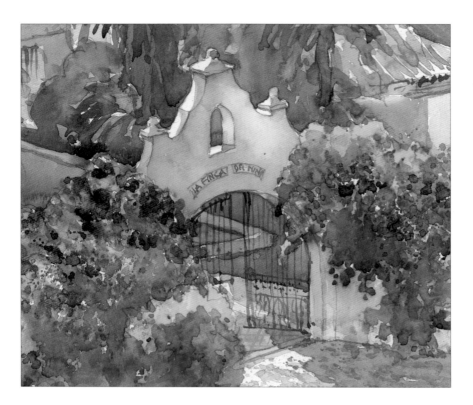

Overlooking the Finca

48 x 36cm (19 x 14in)
Every year I take painting groups to this fantastic location in Andalucia in Spain, set in its own grounds just minutes from the sea. This view of the entrance gates was from the small hill above the Finca. I spotted it on the way back from the 'chicken shack' after a blow-out lunch.

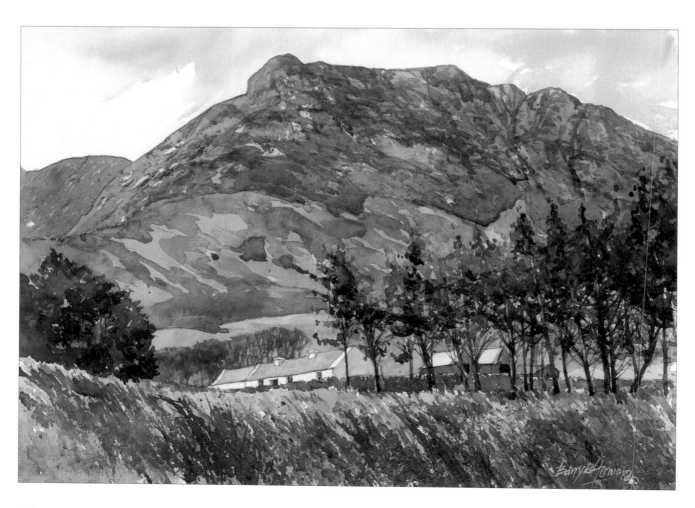

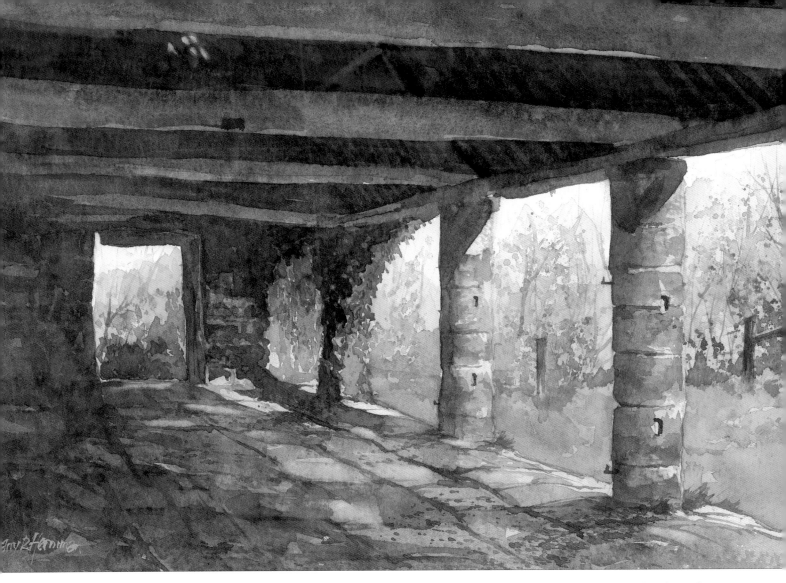

Under the Rafters
40 x 30.5cm (15¾ x 12in)
I found this lovely old barn within the grounds of Woodchester Park
in Stroud while out walking with my brother. It was a bright sunny
day outside and it cast a warm glow into the barn.

Opposite:
Mountains over 'The Field'
48 x 36cm (19 x 14in)
A search for the film location of The Field, which starred Richard Harris,
brought me to this lovely farmstead in Connemara. The actual field that was
made famous by the film is behind the wall, but this view with the mountain
in the background was just too grand to miss.

Pembrokeshire Coastline

Whenever I think of painting a coastline, the Pembrokeshire coast is always very high up on my list. The relatively small stretch of coast from Tenby, going west beyond the 'Green Bridge' changes in appearance from one headland to another.

This rocky outcrop is just around from Freshwater West, and is an incredibly colourful part of the coast – making it a great subject to paint!

The preliminary sketch.

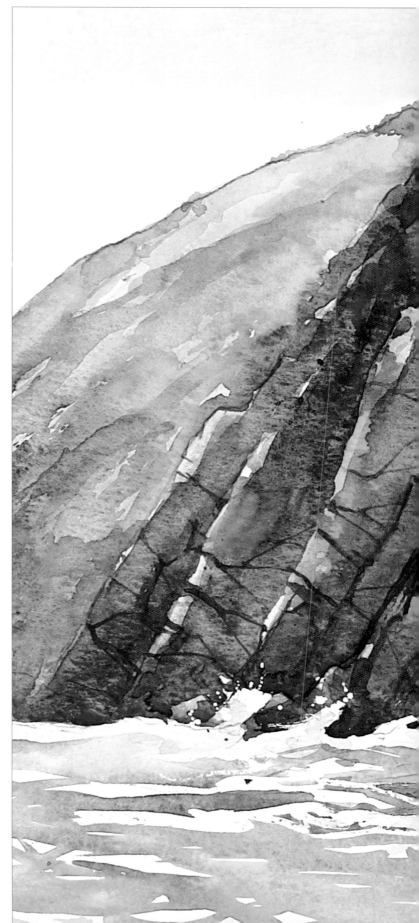

The finished painting.

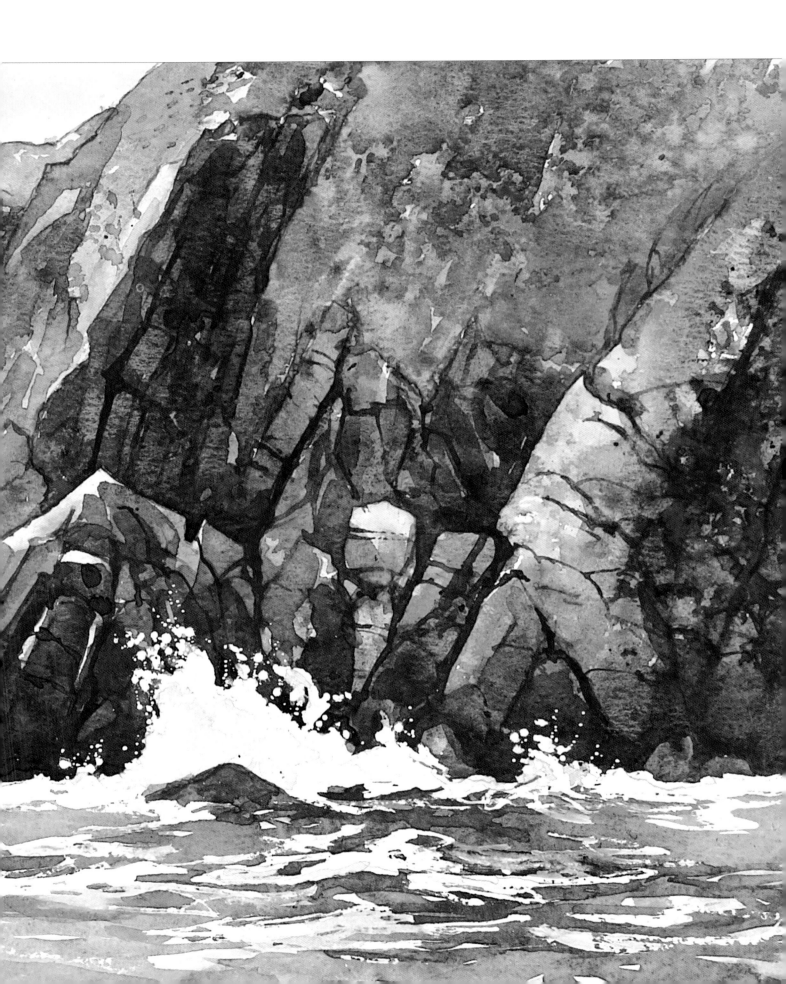

TIP

You need to look into your darks
rather than at them, so keep the paint
fluid to avoid thick, dead passages.
Darks should be semi-transparent,
just like the other colours you use.

1 Use masking tape to create a
border on your paper, then sketch out
the subject with the 2B pencil, and
add masking fluid as shown. I have
tinted the masking fluid with a little
rose madder to help it show up.

2 Prepare cobalt blue and add a
touch of rose madder, then use the
size 12 brush with this mix to paint
a flat wash wet on dry over the sky in
the top left. Vary the tone with a little
more rose madder.

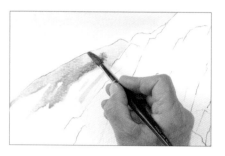

3 Add pure yellow to the hillside
in the top left, and add cobalt blue
wet in wet.

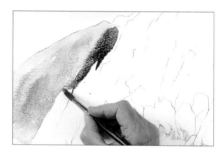

4 Continue down the hillside,
adding rose madder wet in wet to vary
the tones. Begin painting the rocks to
the right with manganese violet.

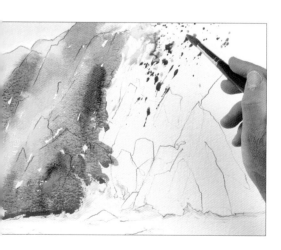

5 Continue creating the variegated
wash across the hillside, using the
colours from the previous steps.
When you reach the far right, begin
spattering the colours down the cliff
face, by flicking the paint at the paper.

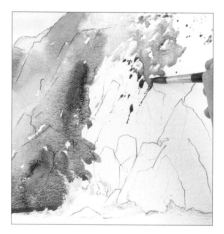

6 While the drops from the
spattering are still wet, tickle them
into place with the tip of the brush.

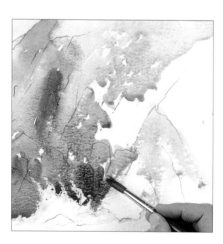

7 Dry brush an Indian yellow and
rose madder mix across the cliff face,
then begin dropping in darks while
the paint is still wet.

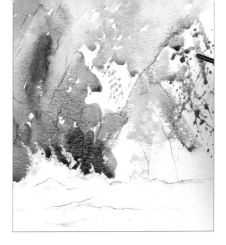
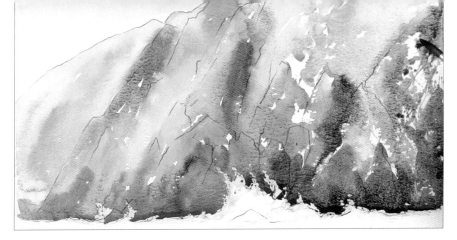

8 Spatter rose madder on the far right of the painting, then use the end of the brush to draw the spattered beads of colour down and create a broken, rocky texture on the cliff face.

9 Add darks around the right and bottom of the painting to create a visual barrier. This helps prevent the eye from wandering out of the picture, and creates a frame around the cliffs.

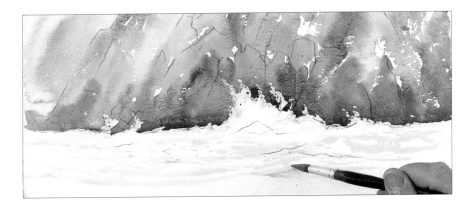
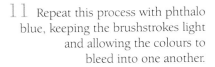

10 Wash the sea with clean water, using broad horizontal strokes, then brush pure yellow across the wet waves.

11 Repeat this process with phthalo blue, keeping the brushstrokes light and allowing the colours to bleed into one another.

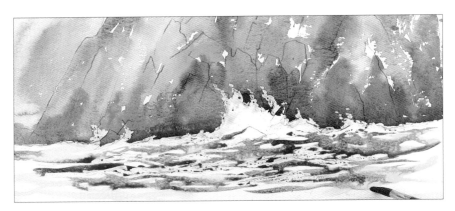

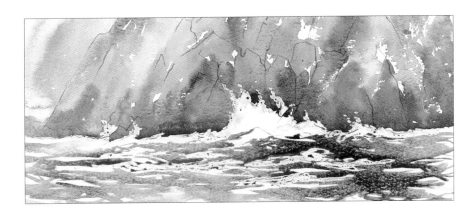

12 Keep the paint moving on the paper, using the tip of the brush to prevent pools of pigment forming. Allow the painting to dry completely before continuing.

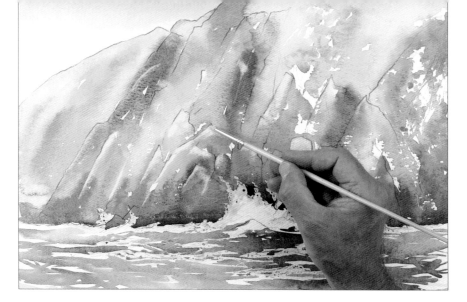

13 Use the hog brush and clean water to lift out highlights on the top of the rocks. This will help to give some form and shape to the rocks.

14 Protect the lighter rocks on the left with your hand and spatter the right-hand side with clean water.

15 Dab the damp area with kitchen paper to lift out and create highlights.

16 Begin adding French ultramarine and other darks to the cliff face, drawing the paint down with the end of the brush as shown.

17 While wet, drop in other colours to these darks to vary the hues on the cliff face.

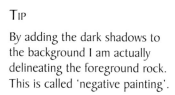

TIP

By adding the dark shadows to the background I am actually delineating the foreground rock. This is called 'negative painting'.

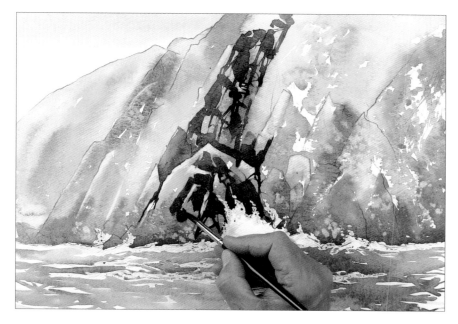

18 Continue this process down the cliff face to the sea.

19 Still using the same colours and techniques, develop the texture on the right of the section you have completed. You can turn the board to help paint the horizontal strata.

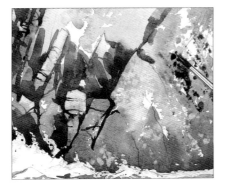

20 Once this area is dry, spatter rose madder and Indian yellow on the far right of the cliff.

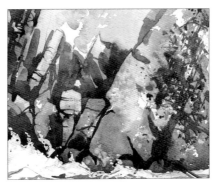

21 Quickly spatter on darks, allowing them to bleed into the warmer colours. Use the end of the brush to draw the colours around.

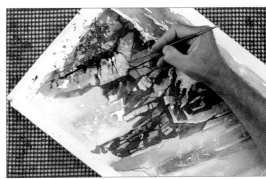

22 Turn the entire board and drag the colours from the dark areas into the light. Use the rigger to draw fine cracks and crevices.

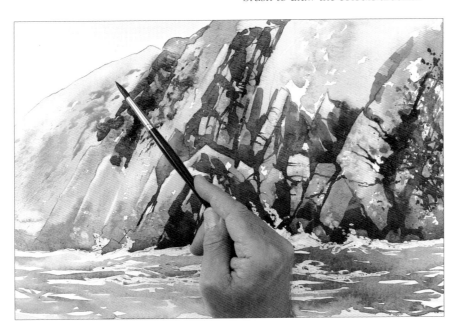

23 Use the size 12 brush to mix dark yellows and blues on the left-hand side of the painting to create the impression of vegetation. Loosely spatter Indian yellow and phthalo blue in the same area to reinforce this impression.

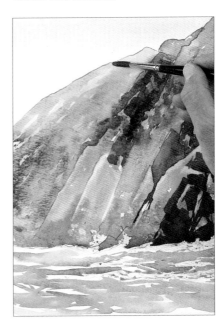

24 Use the tip of the brush to tickle any hard edges away from the foliage area.

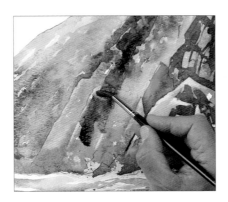

25 Add some rose madder below the foliage area, using broad brushstrokes to create an eye-catching 'hot spot'.

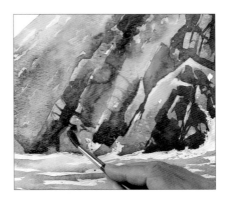

26 Develop this area by spattering manganese violet wet in wet, and drawing it around the hot spot. This has the effect of drawing further attention to the area.

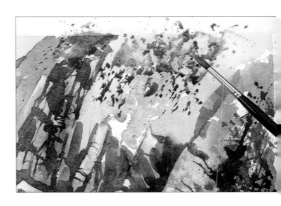

27 Turn your attention to the top right of the painting, and spatter rose madder, Indian yellow and phthalo blue in quick succession.

28 Draw these colours down into the grass on the hillside, and allow to dry.

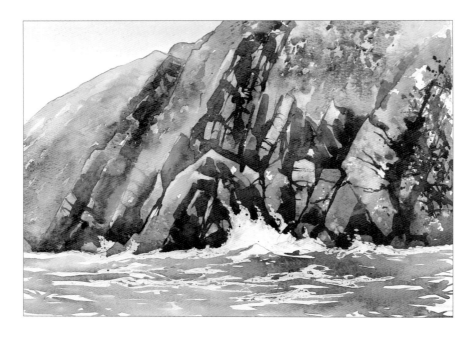

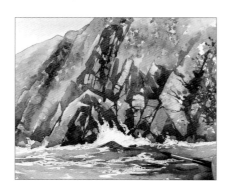

29 Add a touch of water to the sea, and draw the brush lightly and horizontally across the water to create accent brushstrokes with cobalt blue. Allow to dry.

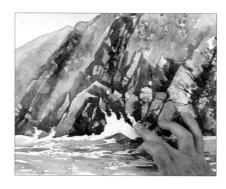

30 Carefully rub off all of the masking fluid with your finger.

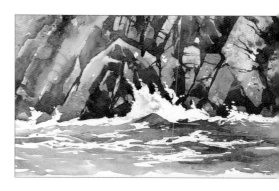

31 Add very dilute mixes of cobalt blue and rose madder in wet in wet to the foam areas to create subtle shading on the bursts of foam.

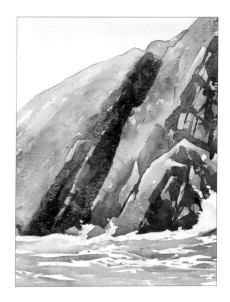

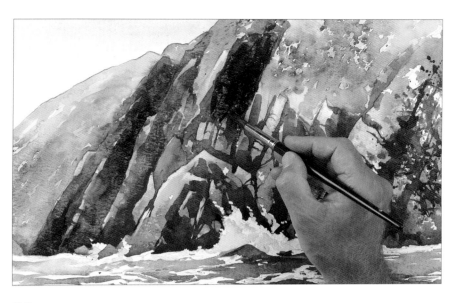

32 Make up very thin washes of cobalt blue, brown madder and cobalt violet, and use the dip dip dip method to work across the rocks on the rocky outcrops on the left.

33 Still using the same thin mixes and the dip dip dip method, continue across the rocky areas of the painting, adding warmer touches of Indian yellow and rose madder to bring the light areas forward.

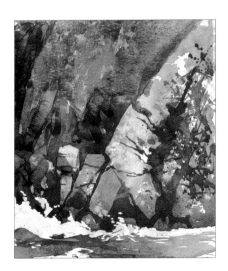

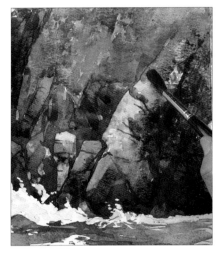

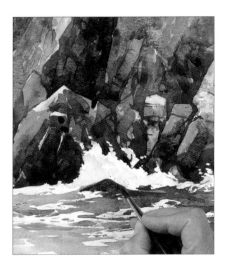

34 Introduce thin cobalt blue and pure yellow washes on the foliage in the top right.

35 Work the dark washes from step 32 over the rocks on the bottom right of the painting, then roll the brush over the rocks to absorb the excess liquid. This will help to create sharp edges to the rocks.

36 Paint the small rocks in the sea using the same mixes used on the cliff rocks. This very dark central rock contrasts very strongly with the pale foam burst.

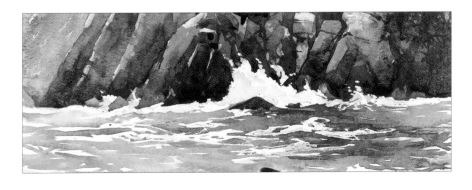

37 Use dilute washes of cobalt blue and phthalo blue to vary the tones in the sea and foam areas.

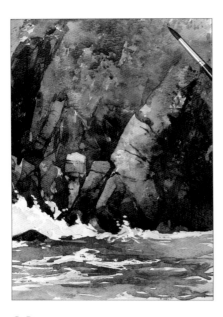

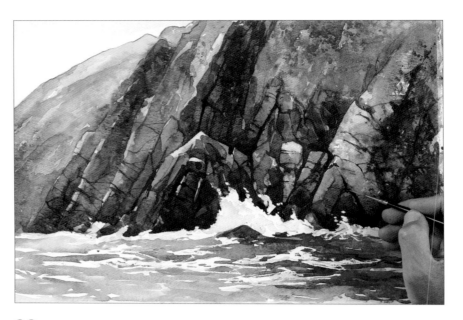

38 Spatter a small amount of these thin blue washes across the top right of the painting.

39 Use the rigger and the dip dip dip technique with French ultramarine, brown madder and cobalt violet to paint cracks and crevices across the rocky areas.

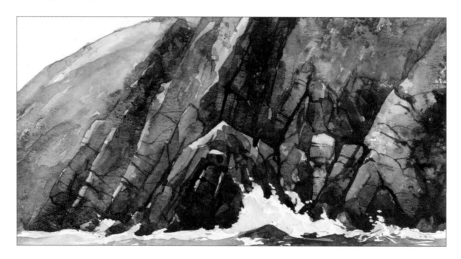

40 While still wet, vary the tones of the rocks with small amounts of the other colours in your palette, and use kitchen paper to soften any edges that appear too stark.

41 Break up the crest of the hill against the sky by adding some gorse with Indian yellow and pure yellow.

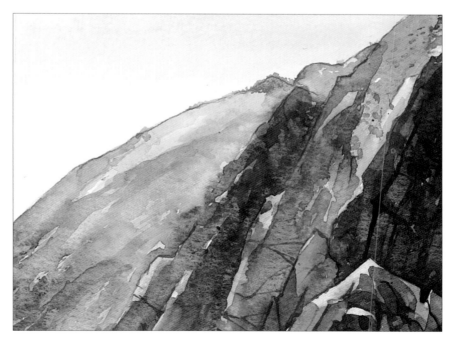

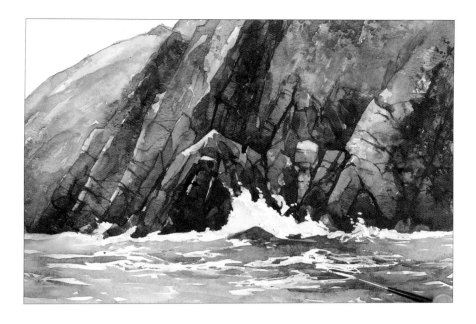

42 Add some thin cobalt turquoise washes on to the sea, and then use the side of the rigger to create foam with neat white gouache.

43 Protecting the higher rocks with your hand, create foam spray with white gouache spattered on to the border between the rocks and the sea.

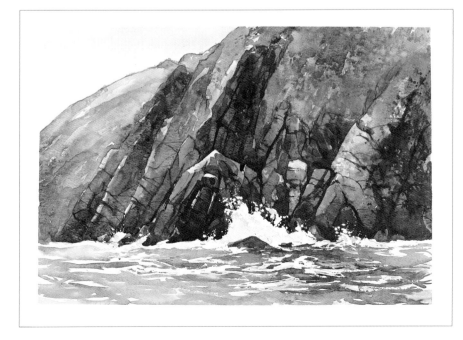

44 Allow to dry thoroughly and then remove the masking tape from the borders to reveal the finished painting.

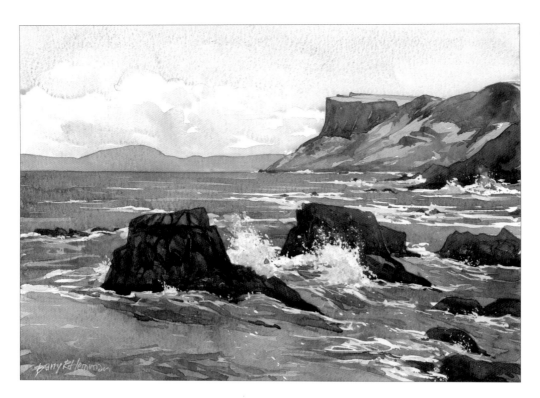

A Strong Swell
40 x 30cm (16 x 12in)
This is a part of Northern Ireland's Antrim coast, and what a fantastic coastline it is. When I went there for the first time, I was really taken with the place. This view is just outside Ballycastle looking towards the prominent outline of Fairhead Cliff, which dominates this area.

Stackpole Cliffs
48 x 36cm (19 x 14in)
Back to Pembrokeshire, and these are some of the impressive cliffs of Stackpole Head. Compare this with pages 58–59 to see how the geology of this part of the coastline is totally different from that at Freshwater West.

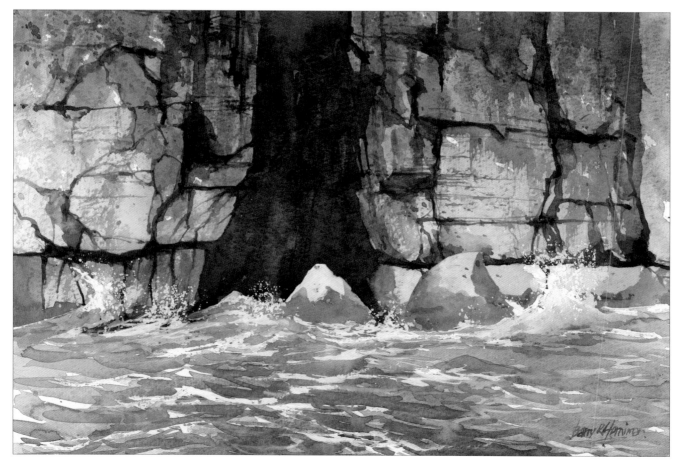

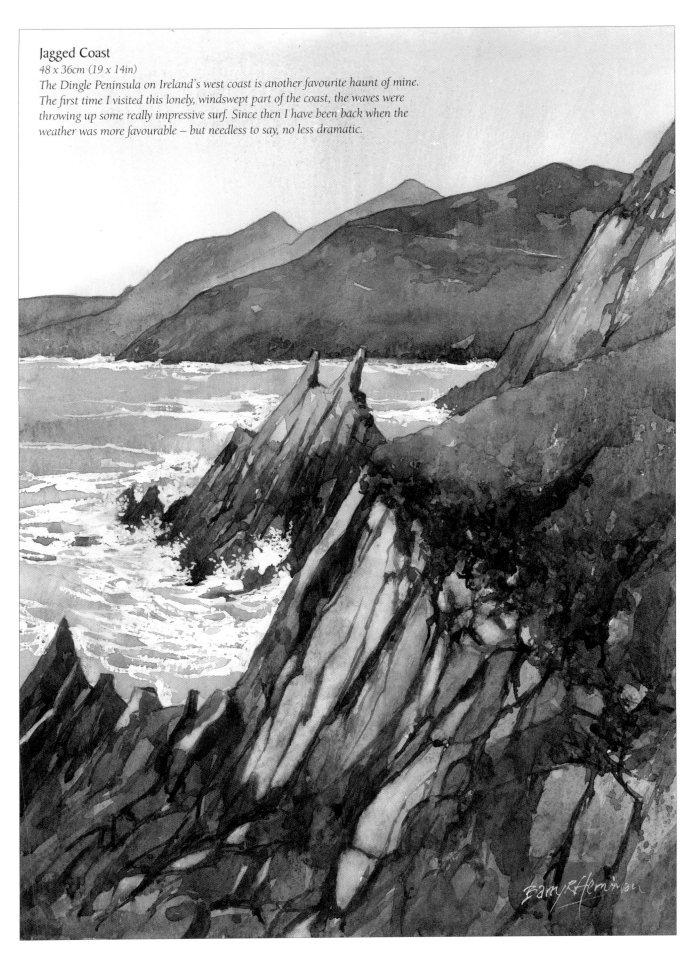

Jagged Coast

48 x 36cm (19 x 14in)

The Dingle Peninsula on Ireland's west coast is another favourite haunt of mine. The first time I visited this lonely, windswept part of the coast, the waves were throwing up some really impressive surf. Since then I have been back when the weather was more favourable – but needless to say, no less dramatic.

Evening Light over the Sentinel

This magnificent peak is part of the Drakensburg range of mountains in South Africa. The Sentinel forms the western boundary of a sweeping escarpment called the Amphitheatre, which featured prominently as the backdrop to the film *Zulu*.

The height of the mountain range is well over 3,000m (10,000ft) and the Tugela River begins its long journey to the sea cascading over this sheer drop.

This view is from the foothills looking up. Catching it in the early evening was a captivating sight and a good exercise in aerial perspective.

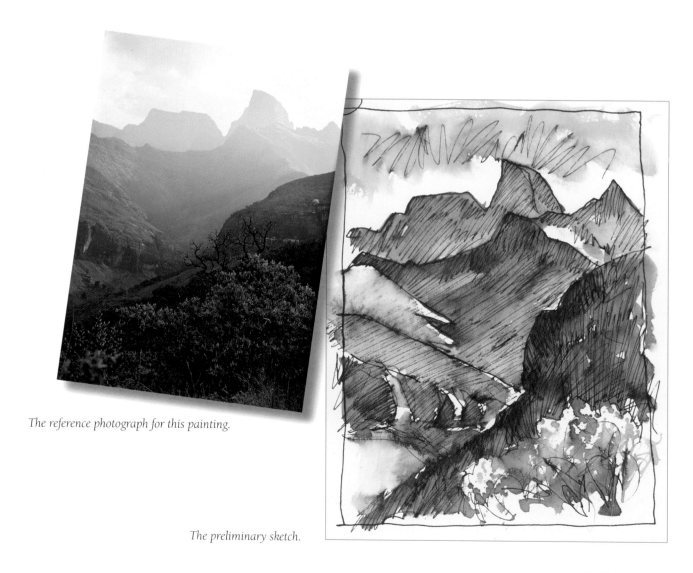

The reference photograph for this painting.

The preliminary sketch.

The finished painting.

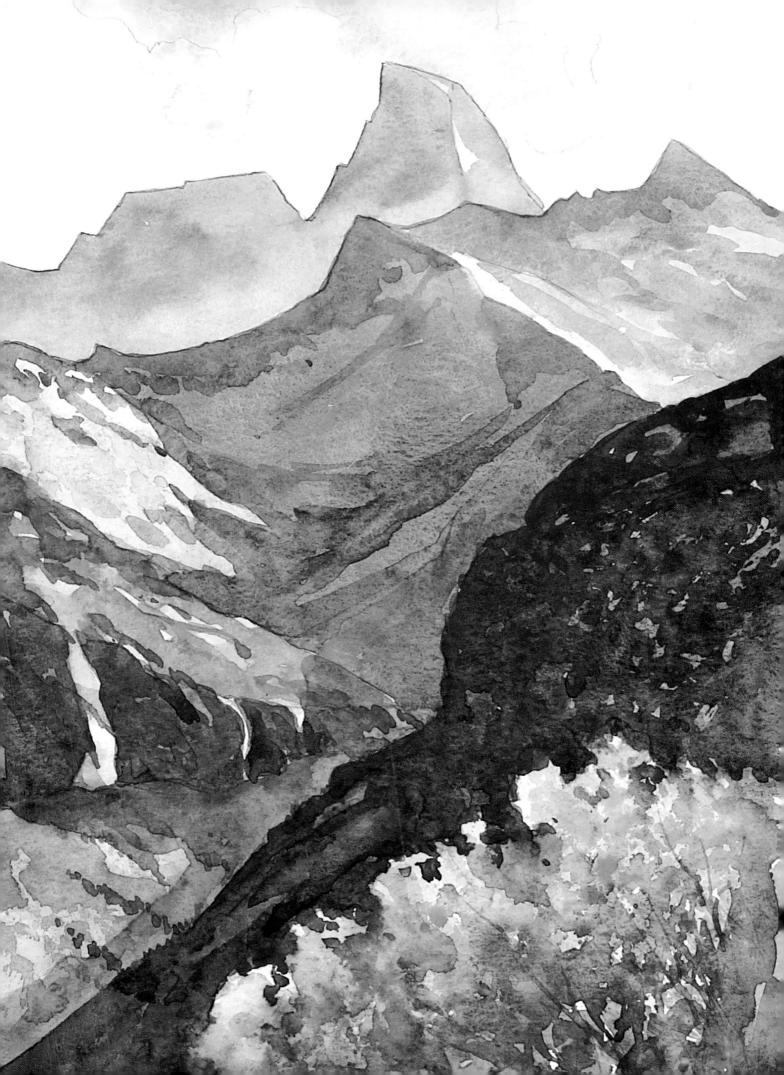

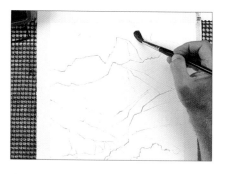

1 Mask the edges of the paper with tape, then use a 2B pencil to make your initial sketch. Wet the sky with the size 12 brush and clean water.

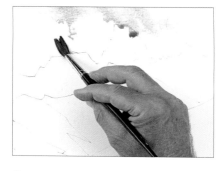

2 Make a broken wash over the sky using cobalt blue and leaving gaps for the clouds.

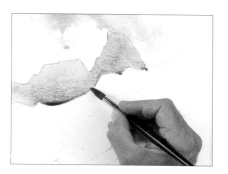

3 Paint the distant hills using a variegated wash of cobalt blue and rose madder.

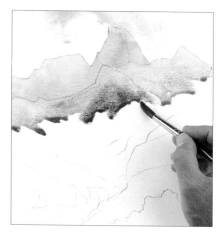

4 As the hills advance, add Indian yellow and a little rose madder to warm the tones.

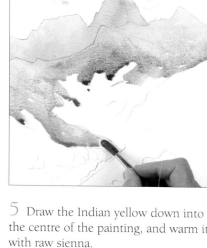

5 Draw the Indian yellow down into the centre of the painting, and warm it with raw sienna.

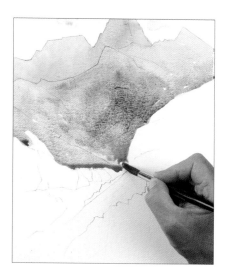

6 Fill the space left above this area with a variegated wash of cobalt blue and rose madder, warmed with a little raw sienna.

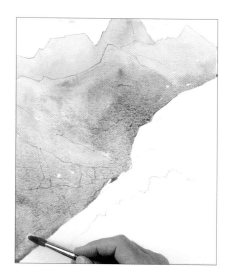

7 Continue using these colours, working down to the bottom left of the painting, strengthening and warming the colours as you go by adding rose madder and raw sienna.

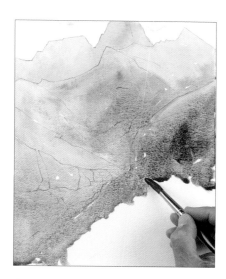

8 Begin the rocks on the right using a rich mix of cobalt violet and rose madder.

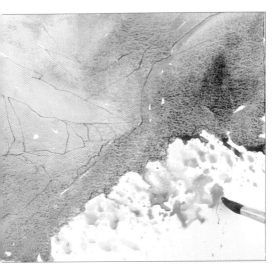

9 Spatter pure yellow into the lower right area, and then spatter phthalo blue on to the same place, allowing the two colours to bleed into each other.

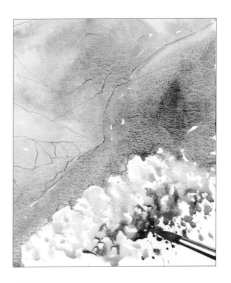

10 Use the tip of the brush to tickle the colours together and draw out branches to suggest foliage.

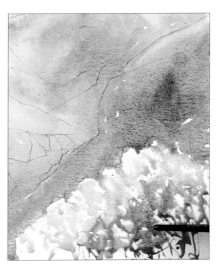

11 Continue developing the branches using the end of the brush to draw out lines for added texture

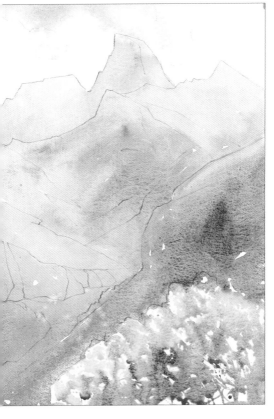

12 Allow the whole painting to dry completely. This forms the underpainting ready for the shadows, which will be glazed over these initial washes to add form to the scene.

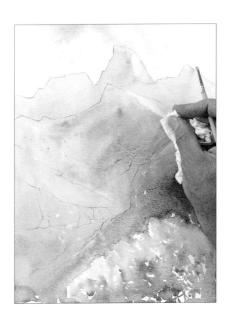

13 Begin to lift out the highlights on the rocks, using the hog brush, clean water and kitchen paper.

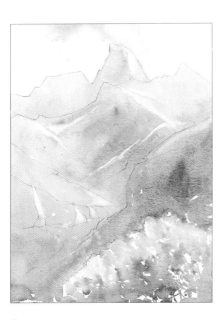

14 Continue lifting out contours on the hillside with the hog brush.

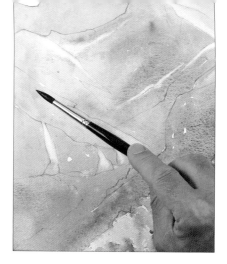

15 Flick clean water on to the left-hand side of the hills.

16 Use clean kitchen paper to dab the wet areas and lift out some of the pigment.

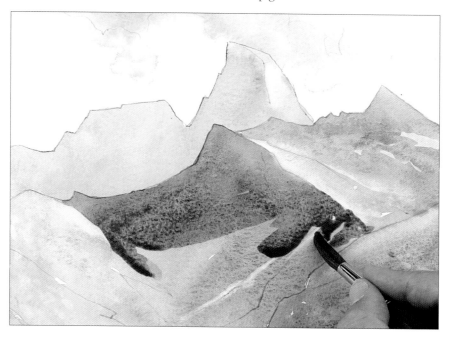

17 Prepare cobalt blue, manganese violet and brown madder, then use the dip dip dip method to strengthen the central hill in the distance.

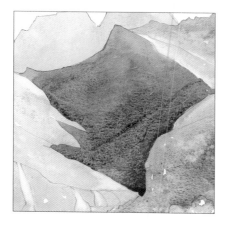

18 Introduce rose madder and raw sienna as you continue down the hill, to suggest warm shadows and bring sharper edges to the sides of the valley.

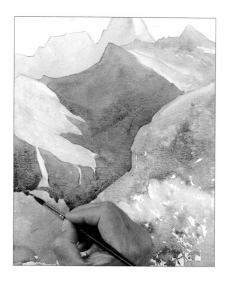

19 Switch to the size 8 brush and use the same mixes to paint the shadows on the left-hand side of the painting.

20 Still using the size 8 brush and the same mixes, work the shadows across the painting right to the bottom left corner.

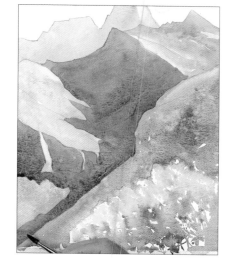

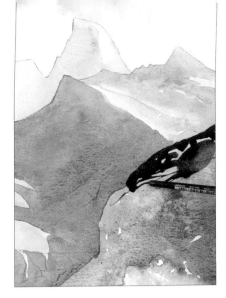

21 Make French ultramarine and burnt sienna mixes to a creamier consistency, and use the size 12 brush to paint the rocks on the right-hand side.

22 Spatter the mixes over the top of the right-hand rocks, protecting the central valley with your hand.

23 Develop the spattered paint into rocky textures with the tip of the brush.

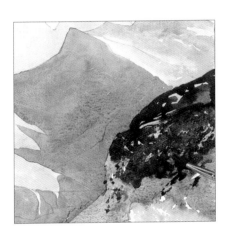

24 Spatter in Indian yellow and pure yellow to add some warmth and light to the rocky area, then continue drawing these colours down the foreground.

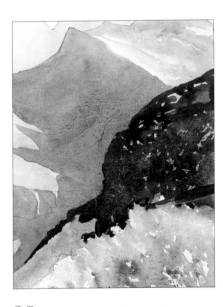

25 When you reach the foliage at the bottom left, hold the brush right at the end to give your brushstrokes the lightest possible touch.

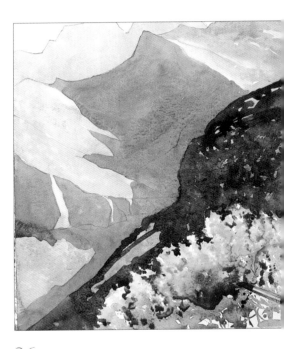

26 When you reach the bottom left corner of the picture with the shadows, flick pure yellow, cobalt turquoise and cobalt blue into the foliage, and use the tip of the brush to encourage the spots of colour to bleed into each other.

TIP

If you want sharp edges to areas of your painting, make sure the adjacent areas are bone-dry.

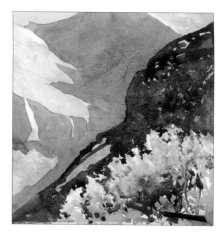

27 Use the end of the brush to create the effect of branches in the foliage, exactly as you did for cracks in the rocks.

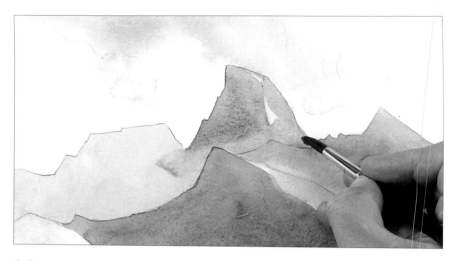

28 Switch to the size 8 brush, and paint a thin variegated wash of cobalt turquoise, cobalt blue and rose madder over the distant mountains to add definition to them.

29 Wash over all the distant mountains in this way, adding water to the bottom of the wash to fade the colour out.

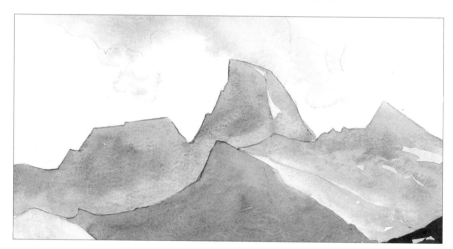

30 Begin to shape and form the mountains in the middle distance with small, neat brushstrokes of cobalt blue and cobalt turquoise.

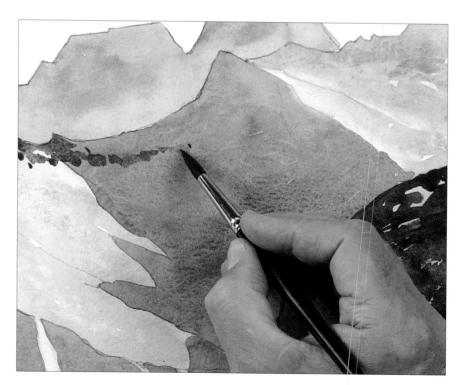

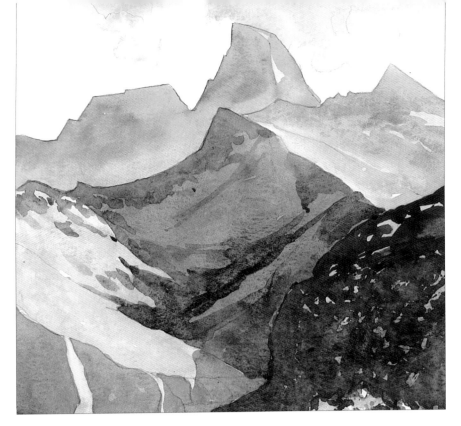

31 Continue detailing and softening the valley area with the dark tones, varying the consistency of the mixes by adding water or additional paint.

32 Make thin washes of cobalt violet and cobalt turquoise and paint the tops of the mid-distance mountains.

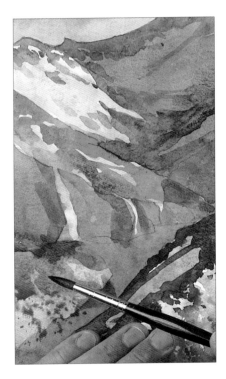

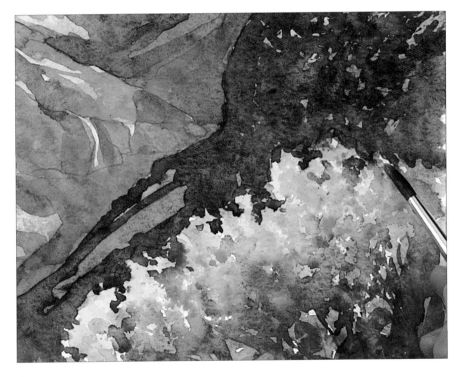

33 Introduce warm tones of Indian yellow and raw sienna into the foreground rocks on the left. Protect the shadow area at the bottom left and spatter warm tones on the very closest rocks.

34 Make a pure yellow wash and paint it into the white highlights on the foliage on the bottom right.

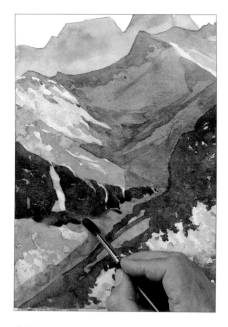

35 Use the darker mixes on your palette to darken the left-hand side of the foreground. Soften the area with water towards the bottom.

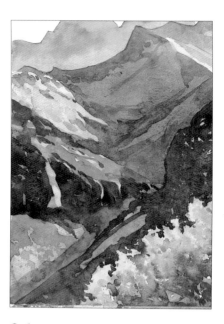

36 Work these areas down into the valley to add form and interest.

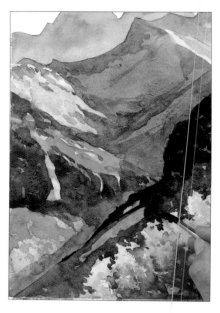

37 Use even stronger mixes of these colours to darken the right-hand side of the foreground. Work carefully around the foliage, cutting in to give the effect of leaves.

38 Work the darks right down to the bottom left of the picture.

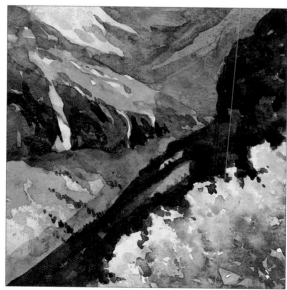

39 Mix a neutral brown from brown madder, cobalt blue and a touch of manganese violet. Use this to add details on the left-hand side as shown.

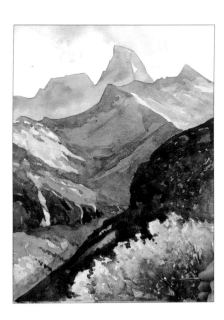

40 Strengthen the right-hand side of the painting with a variegated wash down to the foliage. Develop the area around the bottom of the picture, using the rigger to add branches to the foliage.

41 Finally, knock the lightest tones back with a thin wash of pure yellow over the left-hand trees and the rocks above them. Allow the painting to dry completely, and remove the masking tape from the borders to finish.

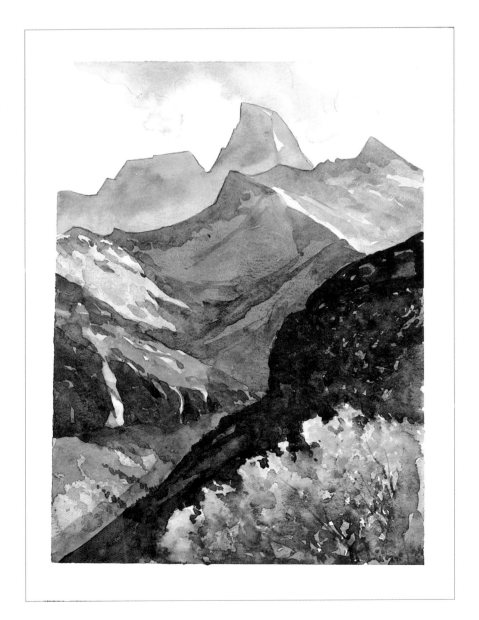

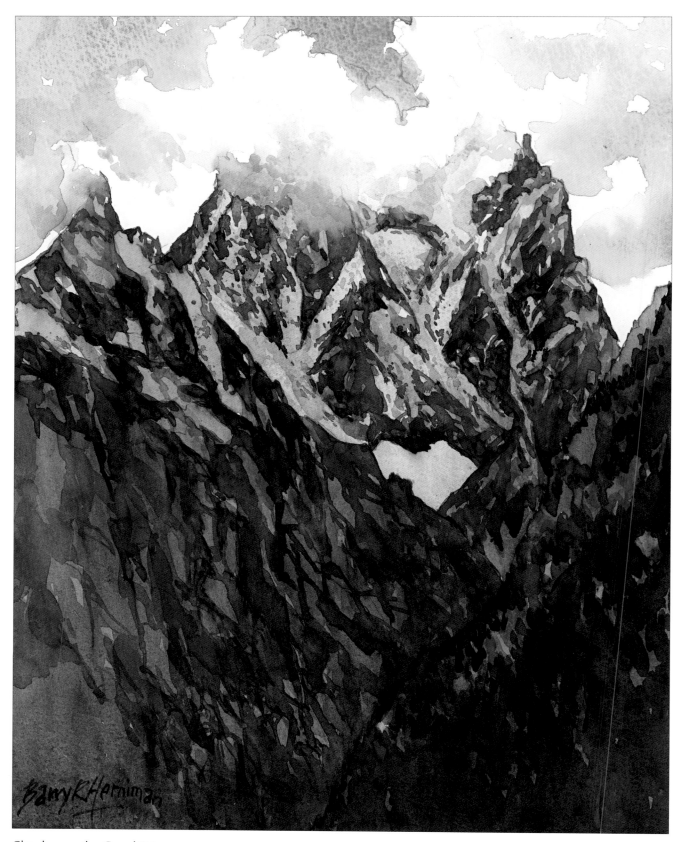

Clouds over the Grand Tetons

48 x 36cm (19 x 14in)
I and my painting group travelled to the Grand Teton National Park in Wyoming;
and to quote the Americans, it was truly 'awesome'! Our first view of the mountains
was somewhat obscured by low-lying cloud, but on this day the clouds lifted
sufficiently for us to get our first glimpse of the 4,000m (13,000ft) plus peak.

The Connor Pass

30 x 30cm (12 x 12in)

The road up to the Connor Pass in Killarney, Ireland, carves its way along the mountainside, and in some places it is only the width of a single track. This is the view looking back at that road.

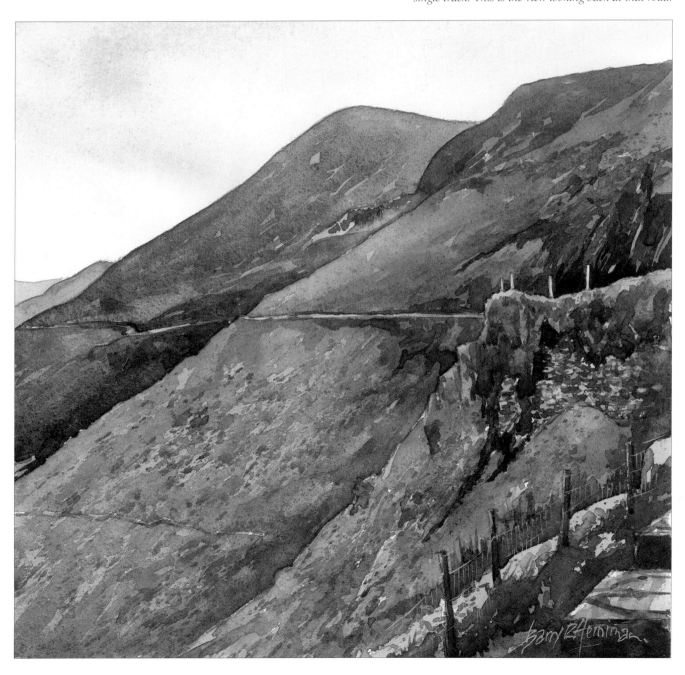

Watendlath Bridge

What a classic example of a packhorse bridge, and what a wonderful setting! This is the tiny hamlet of Watendlath high above Borrowdale in the northern lakes of Cumbria. The single-track lane that leads to it can become quite congested, but we went up late in the afternoon and it was very quiet.

This view is looking upstream towards Watendlath Fell which can just be seen in the distance. The sun was just clipping the top of the bridge and also made the grass bank under the arch glow. This superb scene inspired a painting of strong contrasts and wonderful colour.

The preliminary sketch.

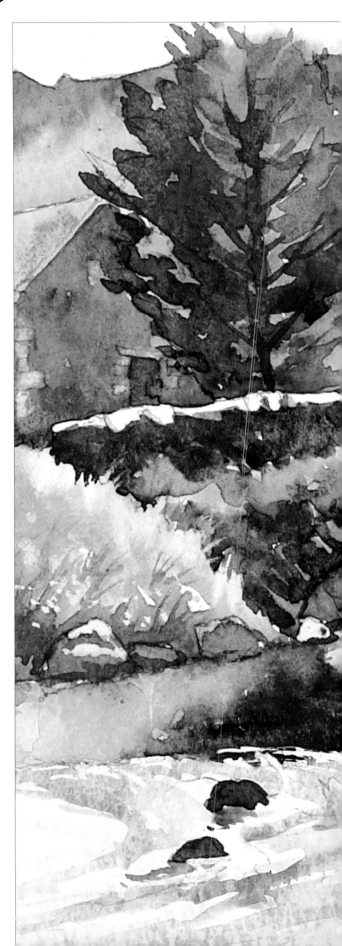

The finished painting.

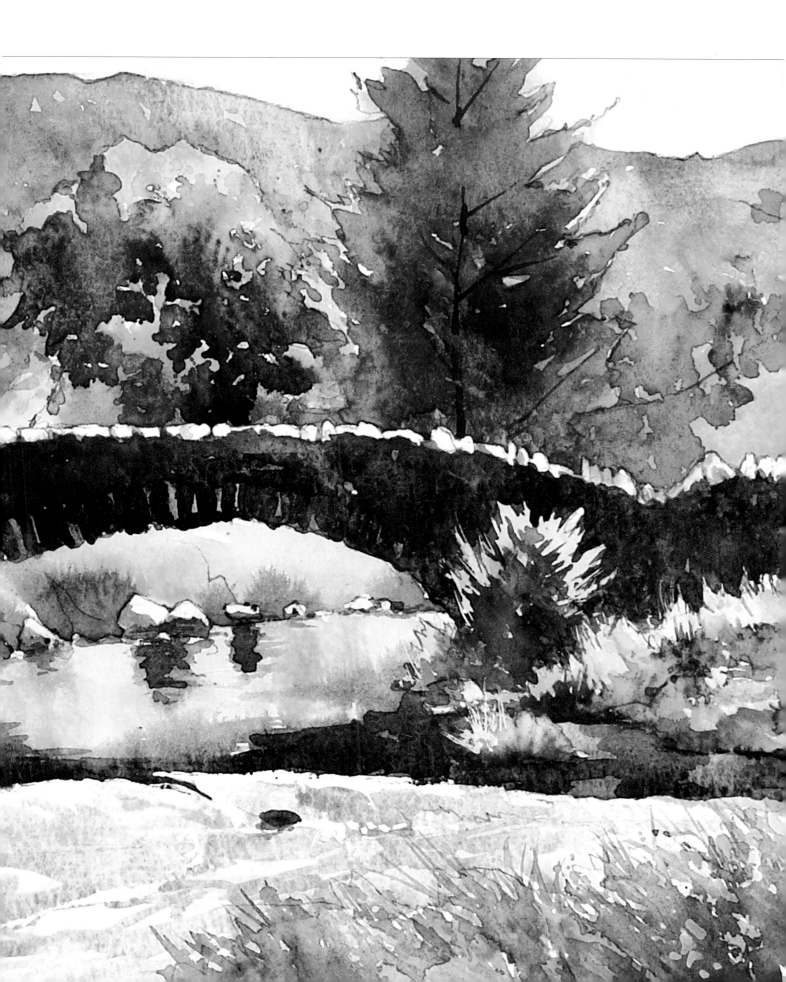

1 Sketch your composition with a 2B pencil and use masking tape to create a border around it. Mask the capping stones on the bridge. This will form a sharp edge against the background and prevent green encroaching on the bridge. Tint your masking fluid with a little watercolour paint to make it clear which areas you have masked. Mask the cascade and rocks on the river's edge.

2 Using the size 8 brush, wet the sky and drop in a thin wash of cobalt turquoise wet in wet.

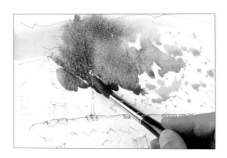

3 Run pure yellow along the left-hand side of the background, then add cobalt blue wet in wet to block in the left-hand tree. The colours will bleed into one another and develop into a steely blue-green.

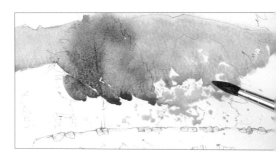

4 Drop cobalt turquoise into the yellow backdrop towards the centre. This will feather into the greens already on the paper.

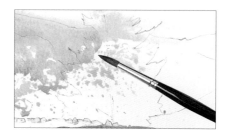

5 Using your hand to protect the bottom of the painting, spatter Indian yellow on to the centre-right of the background.

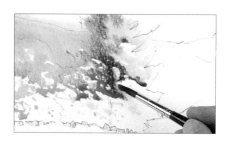

6 Add in touches of cobalt blue to produce a sage green tree.

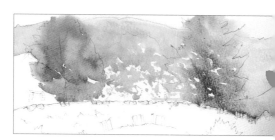

7 Paint a thin yellow wash on the right, then draw the sage green out of the tree into the yellow wash at the bottom. Finally, add touches of cobalt turquoise into the yellow for interest.

84

8 Wet the area between the trees and dot in cobalt blue to suggest foliage.

TIP

If you find greens leaking into the sky, dampen some kitchen paper and lift out the colour before it dries.

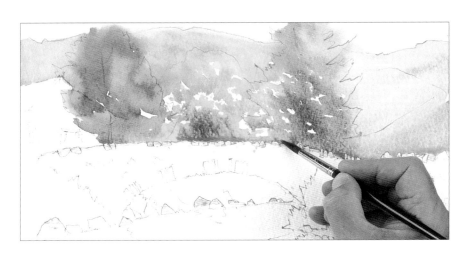

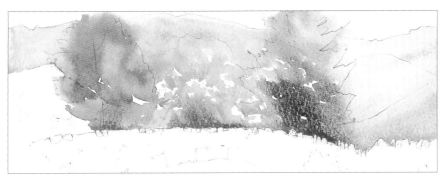

9 Add further shading and texture by painting a little manganese violet to add darker parts to the foliage.

10 Add pure yellow in the centre-left of the painting, and work cobalt blue in wet in wet.

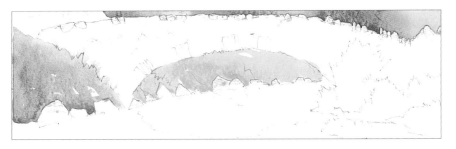

11 Use the end of the brush to tease out long grasses from this area of foliage.

12 Paint the area underneath the bridge with pure yellow, and add a little cobalt blue to the left-hand side for texture.

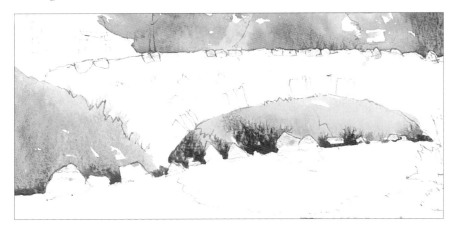

13 Using the tinted masking fluid as a guide, paint around the edges of the riverside rocks with brown madder to help define the river's edge. Allow the brown to bleed into the wet paint under the bridge.

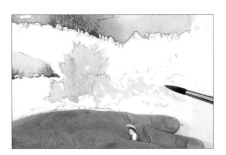

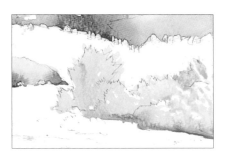

14 Begin the foliage on the right-hand side of the picture by painting a flat wash of pure yellow on the bush to the right of the bridge's arch. Leave some spaces to begin to suggest branches and texture.

15 Create a sharp green by adding a little cobalt turquoise wet in wet. Protect the bottom of the paper with your hand and spatter on pure yellow to the right of the bush.

16 Develop this area further by adding touches of cobalt blue and cobalt turquoise, then vary the very bottom of the foliage with the slightest touches of brown madder.

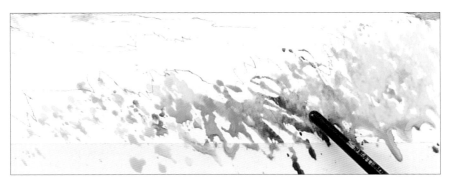

17 Spatter pure yellow followed by cobalt blue and cobalt turquoise on to the foreground to form the foremost grasses. Flick and tickle the grasses into shape with light touches of the tip of the brush.

18 Use the end of the brush to tease out long grasses from this area.

19 Add a wash of clean water into the stream and work a pure yellow wash into the area wet in wet.

20 Paint the stream a light green by adding cobalt turquoise wet in wet. Add cobalt blue on the left where the bank of the river is reflected.

21 Paint the building in the middle distance with the dip dip dip method, using Indian yellow, brown madder and manganese violet.

22 Still using the dip dip dip method and the same three colours, paint the top of the bridge, using the end of the brush to outline stones as you go. Use more manganese violet than in the building.

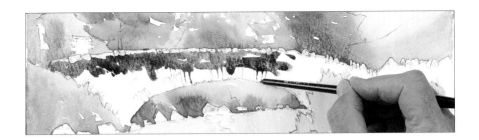

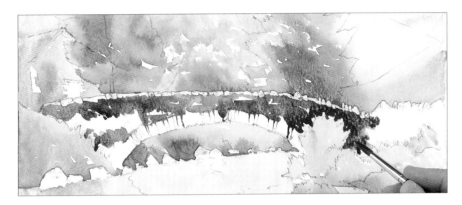

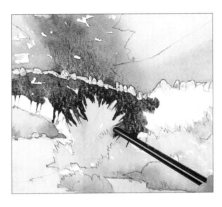

23 Continue filling in the bridge, working from left to right. When you reach the foliage on the right, use darker mixes to create a striking outline.

24 Use the end of the brush to draw the dark colours into the bush to create texture.

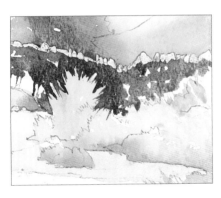

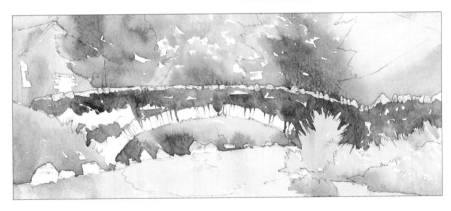

25 Fill in the area to the right of the bridge with cobalt blue, brown madder and Indian yellow. Work right up to and around the masked-out areas.

26 Add a little raw sienna to warm the mix, and vary the tones on the bridge. Pay particular attention to the right-hand side, and define the edges of the foliage by drawing darks out with the end of the brush.

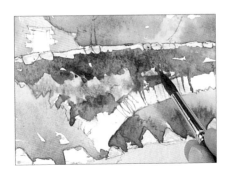

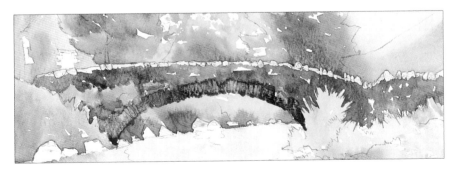

27 Paint in the ivy on the bridge with a variegated wash of pure yellow and cobalt blue.

28 Use cobalt blue and cobalt violet, along with touches of Indian yellow and brown madder to paint the larger arch stones of the bridge. This creates a good counterpoint against the lighter colours of the bank.

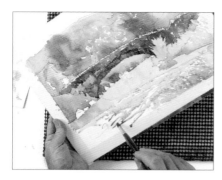

29 Switch to a size 12 brush to wash cobalt turquoise and cobalt blue into the bottom of the picture with horizontal brushstrokes. Tilt the picture to help the paint flow sideways.

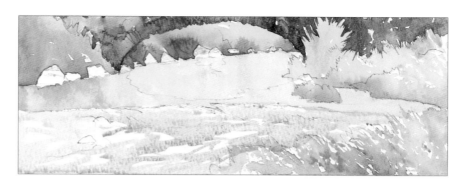

30 Continue to paint the water area, but do not fill in all of the white space. Leave some patches of paper showing through for highlights.

31 Paint the door on the building with a variegated wash of brown madder and cobalt blue.

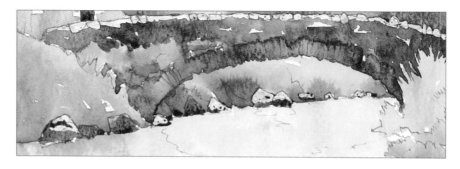

32 Paint the rocks on the riverbank with the same colours, painting over and around the masking fluid.

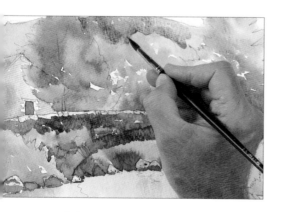

33 Vary the background hills with the dip dip dip method, using brown madder, manganese violet and cobalt blue. Start in the centre and work towards the edges of the trees.

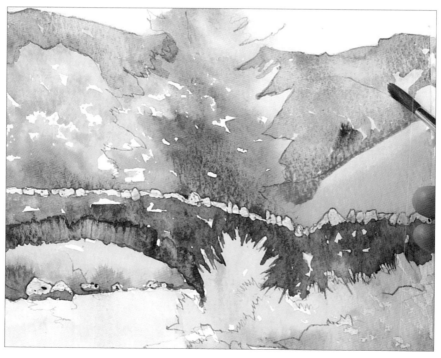

34 Paint the distant hills on the top right with the same colours and techniques.

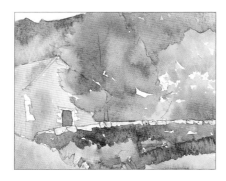

35 Work the same colours into the top left. Prepare some dark mixes of French ultramarine and brown madder for the mid-distance foliage.

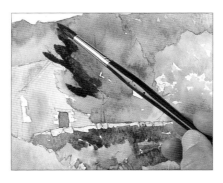

36 Start with the fir tree, using the side of the brush for the distinctive shapes of the branches.

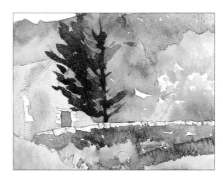

37 Draw the major branches and the trunk with the end of the brush and brown madder.

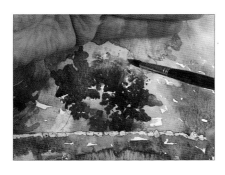

38 Paint the central tree with brown madder and French ultramarine, then spatter pure yellow into the area.

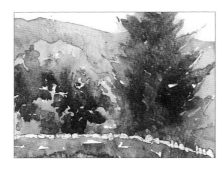

39 Work Indian yellow and phthalo blue to the tree on the far right, then shade and vary the foliage with manganese violet.

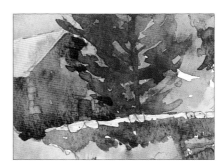

40 Paint the gable end of the building with manganese violet, cobalt blue and brown madder, using the dip dip dip technique.

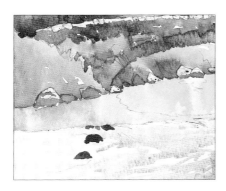

41 Fill in the rocks in the stream with the same colours.

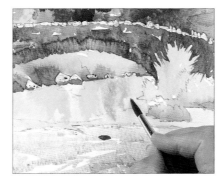

42 Wet the river area and drop in pure yellow and phthalo blue to variegate the water.

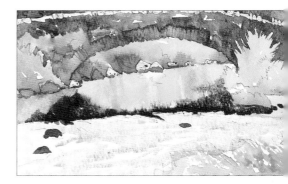

43 Use manganese violet and French ultramarine to create the reflection of the bridge in the stream.

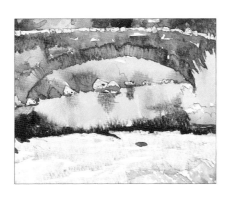

44 Use thinner mixes of the same colours for the reflections of the riverbank rocks.

45 Still using these thin dark mixes, continue painting shaded areas to the right of the stream.

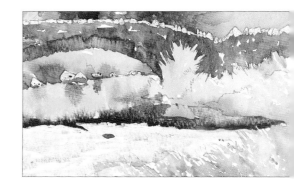

46 Tilt the board and draw the reflection of the rocks out horizontally.

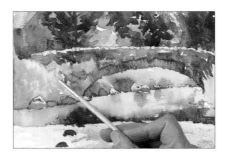

47 Lift out highlights on the foliage to the left of the bridge.

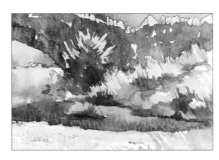

48 Use the rigger to detail the foliage to the right of the bridge, using the dip dip dip technique with pure yellow, cobalt blue, rose madder and manganese violet.

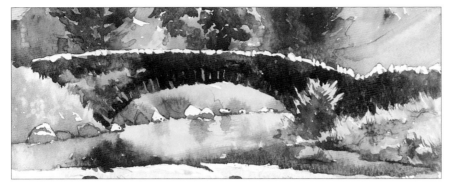

49 Rub off the masking fluid, then unify and darken the wash on the bridge with the size 8 brush and a variegated wash of cobalt blue, rose madder and manganese violet. Use the end of the brush to tease out detail.

50 Use clean water and the hog brush to lift out the coping stones around the door of the building.

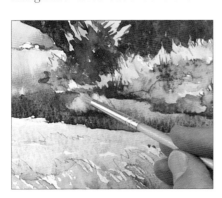

51 Still using the hog brush and clean water, lift out short vertical strokes to create grasses by the river.

52 Using the size 8 brush with pure yellow, paint the area in the top right, then drop in cobalt blue to form shadows and texture in the foliage.

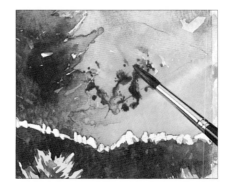

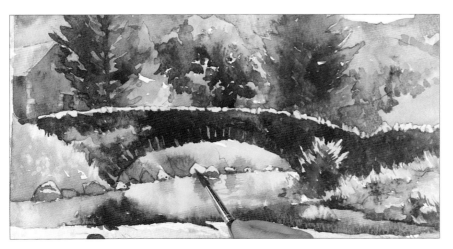

53 Continue developing the trees and foliage in this area, then use pure yellow and rose madder to paint the top stones on the bridge and the rocks in the river.

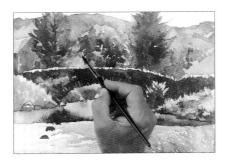

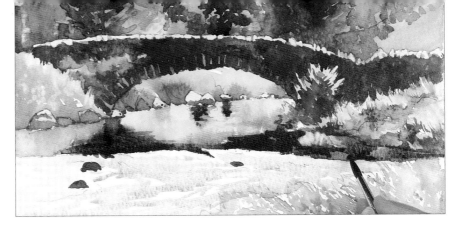

54 Use greens made with the dip dip dip method, cobalt blue and pure yellow to fill in any remaining white spaces in the background foliage.

55 Deepen the reflections of the rocks in the river using the dip dip dip technique with cobalt turquoise and manganese violet. Vary the foliage colours in the bottom right with Indian yellow.

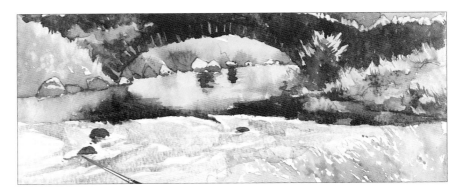

56 Drop clean water into the river, and use cobalt turquoise and manganese violet to vary the colour of the river. Keep the paints fluid, and tilt the board to help them flow.

57 Switch to the rigger to draw the wet paint around the rocks in the river, and give a sense of movement and flow to the water. Add brown madder wet in wet to suggest broken reflections of the rocks in the fast-moving river.

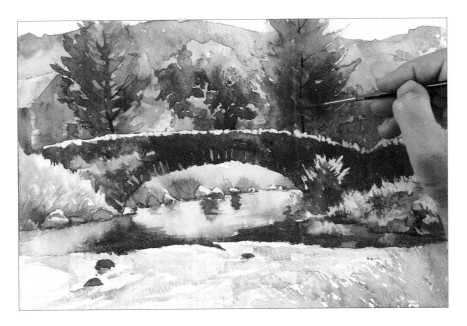

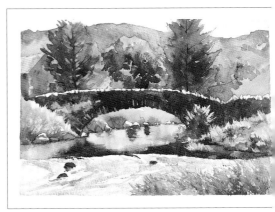

58 Mix white gouache with brown madder and cobalt blue to pick out the final details of the trunks and branches in the trees behind the bridge. The gouache adds opacity to the paint, and helps it stand out from the dark mass of the tree, breaking it up without dominating the composition.

59 Remove the masking tape to reveal a crisp border to your finished piece.

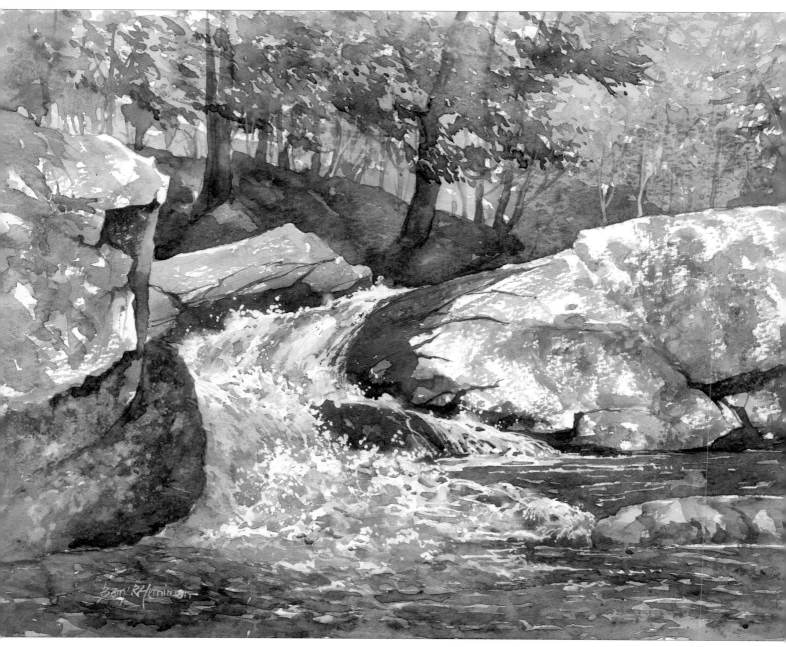

Buttermilk Falls

48 x 36cm (19 x 14in)
*A lovely quiet backwater in New England, only a short distance
from our lodgings in the heart of Vermont's lake district. We were
able to sit right on the water's edge to paint these falls.*

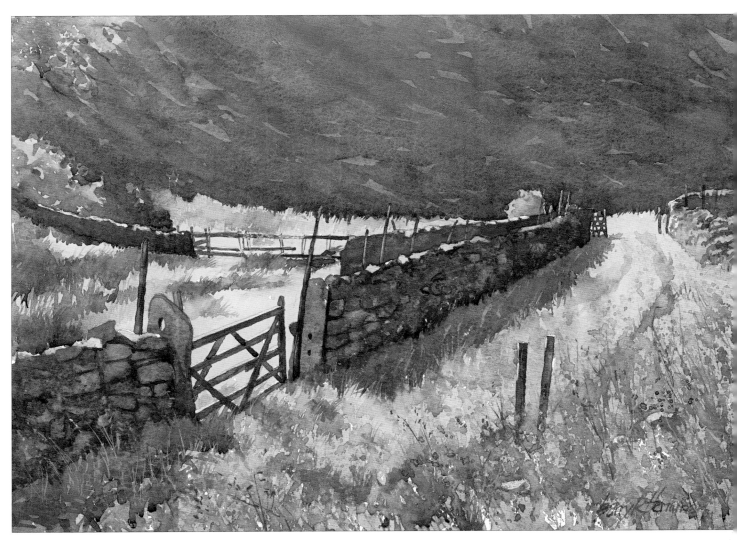

Field Tracks

48 x 36cm (19 x 14in)

On the way back from Watendlath, I passed this scene and was really taken by it. It is a very simple scene, but one that I think captures the tranquillity of late afternoon light on the fields. Plenty of rich transparent glazes here!

Conclusion

Painting can put you on an incredible high when it goes well, but can be really frustrating when it does not. We all have a preconceived idea of how we want our picture to turn out, and when it does not live up to our expectations, disappointment can creep in.

It is good to be self-critical: it shows you how to improve and stops you getting complacent. However, you can be too self-critical and denounce everything you do as 'not good enough'. This can hamper your improvement just as much.

Always take the bits that did work and build on them. Accentuate the positive and move on to the next painting.

Keep a sketchbook, preferably one that contains a good watercolour paper, and put everything in it – doodles, exercises, sketches. Not only will this provide good reference material, it will also act as a yardstick for your progression. Too often, first attempts are relegated to the dustbin so there is nothing to refer to when charting your progress.

I hope I have managed to impart some of my enthusiasm for this wonderful medium, and in doing so shown you how you can bring your watercolours alive with successful and creative washes.

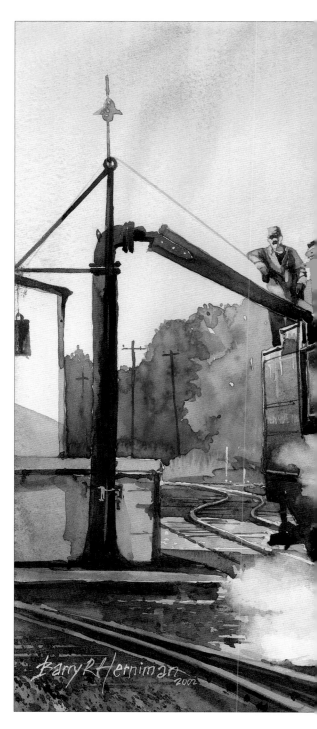

Wild Seas, Dingle Peninsula
24 x 32.8cm (9½ x 13in)
A small demo done on a very wet day. We were allowed to work inside the bar of the hotel, which proved to be a great temptation. We had had some glorious days previously, so it was a good chance to catch up on some painting practice.

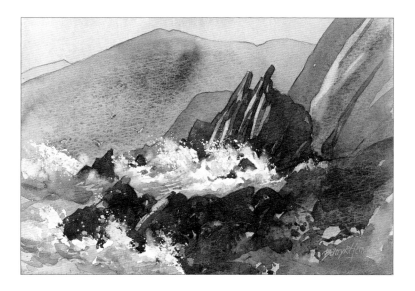

94

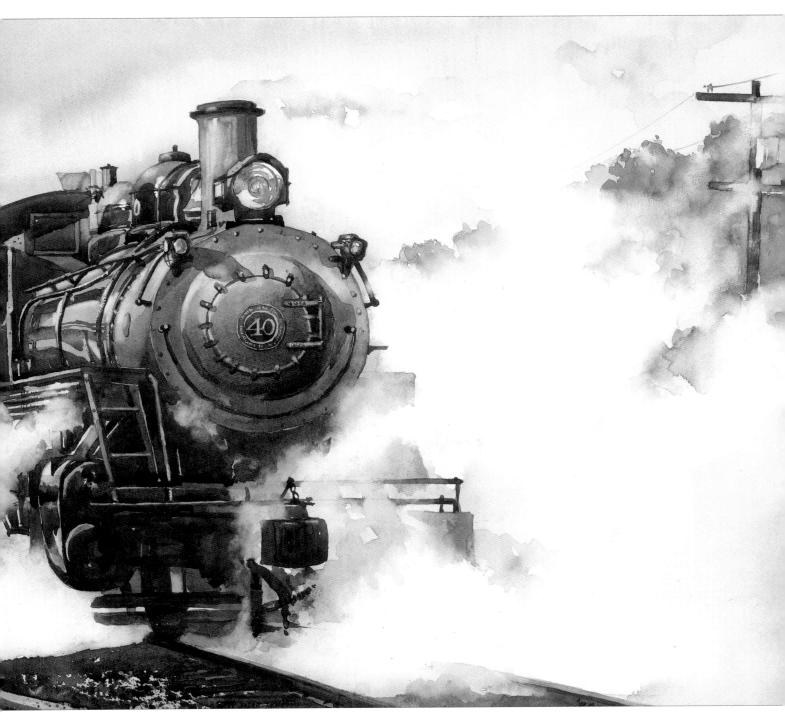

Letting off Steam

56.5 x 35cm (22¼ x 13¾in)

This lovely old steam locomotive was taking on water prior to its short trip up along the Delaware River and back. The train was some way down the track from the station when the driver originally let off steam – so I walked down and asked if he would do a repeat performance for me, and he duly obliged. I thought this train was rather a large specimen until I was shown into the engine shed where they were restoring another engine. Now that one was huge!

Index

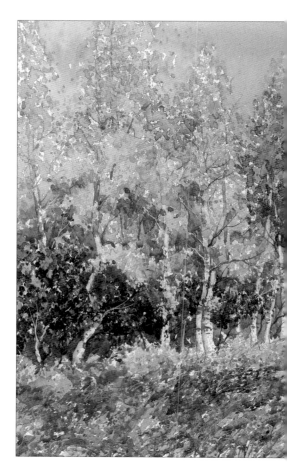

Aspen Gold
36 x 48cm (14 x 19in)
*This magnificent foliage would greet us
each morning from the windows of our
lodgings in Idaho, USA.*